THE LANGUAGE OF **NATIVE AMERICAN BASKETS**

THE LANGUAGE OF NATIVE AMERICAN BASKETS

From the Weavers' View

BY BRUCE BERNSTEIN

NATIONAL MUSEUM OF THE AMERICAN INDIAN

SMITHSONIAN INSTITUTION

WASHINGTON AND NEW YORK

Publication of *The Language of Native American Baskets: From the Weavers' View* was made possible in part through the generous support of an anonymous donor.

Head of Publications, NMAI:
 Terence Winch
Editor: Holly Stewart
Designer: Steve Bell
Design Assistant: Renu Pavate

For information about the National Museum of the American Indian, visit the NMAI Website at www.AmericanIndian.si.edu.

First edition
10 9 8 7 6 5 4 3 2 1

Library of Congress Cataloging-in-Publication Data
Bernstein, Bruce.
 The language of Native American baskets : from the weavers' view /
Bruce David Bernstein.— 1st ed.
 p. cm.
Includes bibliographical references.
 ISBN 0-9719163-1-4
 1. Indian baskets—North America—Themes, motives--Catalogs. 2. Indian baskets—North America—Classification—Catalogs. 3. National Museum of the American Indian (U.S.)—Catalogs. I. National Museum of the American Indian (U.S.) II. Title.
 E98.B3B47 2003
 746.41'2'08997—dc22

2003019004

The Language of Native American Baskets: From the Weavers' View is on view at the National Museum of the American Indian at the George Gustav Heye Center in Manhattan through January 9, 2005.

The National Museum of the American Indian, Smithsonian Institution, is dedicated to working in collaboration with the indigenous peoples of the Americas to protect and foster Native cultures throughout the Western Hemisphere. The museum's publishing program seeks to augment awareness of Native American beliefs and lifeways, and to educate the public about the history and significance of Native cultures.

Photo Credits:
Front cover: Ernest Amoroso, back cover and title page: Walter Larrimore. Half title page: Partially completed twined basket, Pomo, ca. 1905. Yokaya Rancheria, California. Photo by Grace Nicholson. p. 5: Miniature baskets, ca. 1910. Pomo, central California. p. 14: Basketry technique illustrations by Reneé Roberts. p. 22: Lisa Telford (Haida), 2001. Photo © 2003 by Bruce Husko, courtesy of Tohono O'odham Community Action. p. 32: Theresa Secord Hoffman (Penobscot), 2001. Photo © 2003 by Bruce Husko, courtesy of Tohono O'odham Community Action.

Contents

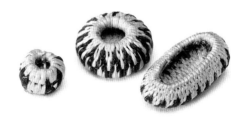

Foreword

In the early stages of this project, Bruce Bernstein, Assistant Director for Cultural Resources at the National Museum of the American Indian (NMAI), invited five Native basket-weavers and one Native basketry scholar to review the outline and object selections he had made for this book, and for the exhibition of the same name at NMAI's George Gustav Heye Center in New York. This curatorial committee endorsed Bruce's approach—a discussion of Native basketry that focuses on the process of basketmaking—and their questions and comments helped him hone his ideas. Most important to everyone was that the museum stress that Native basket-makers are still here, still working within traditions they value to create new and highly original work.

The community of American Indian weavers, in fact, has been growing since the early 1990s, when a number of Native individuals and organizations, inspired by the basketry groups of the early 20th century, founded several new tribal or regional weaving associations. Through these associations, weavers are addressing such challenges as the scarcity of raw materials or their limited access to them on public and private lands, health risks from the use of pesticides and herbicides at plant-gathering sites, and the issue of non-Native people making and selling baskets as "Indian-made." These groups also encourage young people to learn basketmaking. Some associations have combined basketry classes with Native language lessons and workshops in other traditional skills, helping to preserve the rich heritage of their cultures and to keep the spiritual aspect, as well as the technical craft, of basketmaking vibrant.

In *Creation's Journey: Native American Identity and Belief*, one of the first books published by NMAI ten years ago, Tuscarora artist and writer Rick Hill shared a story told to him by Barre Toelken, of the University of Oregon, about Mrs. Matt, a northern California Indian who taught basketmaking there. For the first three weeks of the course, she taught the students songs. When they became impatient, she explained that these songs are sung to show respect to the plants when basketry materials are gathered. So the students learned the songs and went to pick the plants to make their baskets. Back in the classroom,

Mrs. Matt began to teach them the songs to sing while they softened the materials. Exasperated, the students complained that they were still not making baskets. "You're missing the point," Mrs. Matt told them: "A basket is a song made visible." I'm confident that you share the pride and optimism I feel when I think of new generations of basket-makers weaving songs into being.

The museum is grateful to the curatorial committee—Pat Courtney Gold (Wasco–Tlingit), Theresa Hoffman (Penobscot), Terrol Johnson (Tohono O'odham), Julia Parker (Pomo), Lisa Telford (Haida), and Dr. Sherrie Smith-Ferri (Dry Creek Pomo)—for their insights, which inform this work far beyond the brief comments excerpted in these pages. Several basketry organizations contributed objects and images to the exhibition; our thanks go to the Californian Indian Basketweavers Association, the Maine Indian Basketmakers Alliance, the Tohono O'odham Basketweavers Organization, the Northwest Native American Basketweavers Association, and the Great Basin Native Basketweavers Association.

Dr. Bruce Bernstein's years of experience studying the Native cultures of the American West are reflected throughout this project. Dr. Ann McMullen, also of the NMAI department of cultural resources, contributed her vast knowledge of baskets and identified the eastern North American and Arctic baskets shown here. Curatorial assistant Amber Lincoln provided vital research support, as well.

Heye Center collections manager Dominique Cocuzza, project coordinator for conservation Hélène Delaunay, Eric Satrum, Marian Kaminitz, and the museum's registration and conservation staffs were instrumental in preparing the baskets for display. Project manager Lindsay Stamm Shapiro kept the strands of the exhibition from becoming hopelessly knotted. Gerry Breen designed the dynamic gallery spaces, and Stacey Jones directed installation of the exhibition. Susanna Stieff did the beautiful exhibition graphics. Thanks are also due to Heye Center director John Haworth (Cherokee), administrative assistant Bob Mastrangelo, exhibitions head Peter Brill, and Johanna Gorelick, coordinator of education.

The photographs in this book were taken by members of Scott Merritt's terrific move team at the museum's former Research Branch in the Bronx and by the photo services staff, managed by Cynthia Frankenburg. Lou Stancari contributed photo research. This book would not have been produced without the commitment of the NMAI office of publications, especially Terence Winch, head of publications, and Ann Kawasaki. Steve Bell brought his trademark dedication to creating the handsome look of this catalogue. He was ably assisted by graphic designer Renu Pavate. Holly Stewart lent her clear-eyed perspective to the editing of this text.

Finally, on behalf of the museum, I offer my most sincere thanks to the anonymous donor whose generosity helped fund this book.

W. RICHARD WEST
(Southern Cheyenne and member of the Cheyenne and Arapaho Tribes of Oklahoma)
Director, National Museum of the American Indian

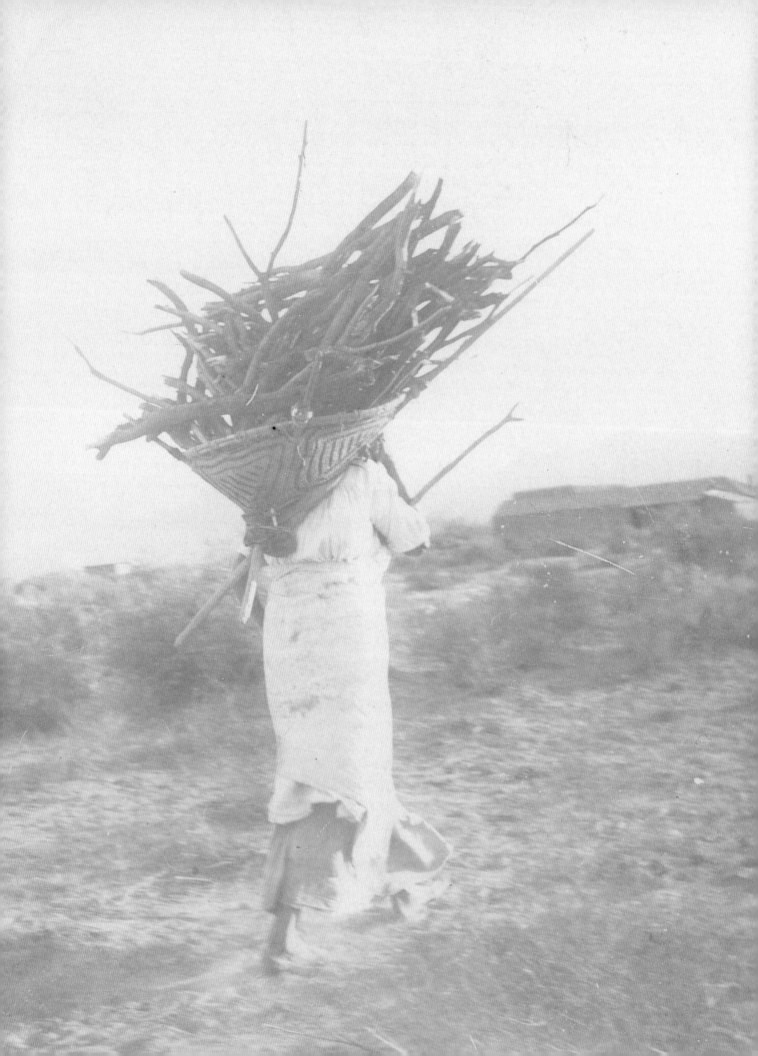

The Language of Native American Baskets

*He was sitting by his campfire, listening to the star echoes. His burden basket
rested upright against a pine.*

The voices inside the basket got pretty loud and disturbed Coyote.

*He stuck his head inside the basket and said, "You people be more quiet
or I'm going to dump you out all over the world."*

They didn't make another sound for many, many eternities.

—from *Elderberry Flute Song: Contemporary Coyote Tales*, by Peter Blue Cloud (Mohawk)

In earlier days, baskets accompanied Indian people throughout their lives.
Meals were prepared and cooked in them, and worldly goods were stored in
them. Babies were carried in baskets, and baskets were given as gifts to mark
an individual's entrance into and exit from this world. As the scene described
above by writer Peter Blue Cloud makes clear, many Native American people
believe that baskets were not given to humankind during the Creation, but had
already been part of the world for many eternities.

Baskets continue to occupy an important place in the lives of many American
Indian peoples. Baskets serve Indian families as valued heirlooms and markers
of cultural pride. Some baskets are used on religious occasions. And hundreds of
weavers make baskets for sale. In Native communities throughout North Amer-
ica, people are teaching and learning basketweaving as part of cultural revital-
ization. Baskets and basketmaking have become central to these communities
because they are part of people's understanding of their world.

Non-Native collectors, scholars, and curators have used a number of different
systems to describe and classify baskets. Many of these systems are based upon
the specific interests of the people who do the classifying, and they generally
use terms from the classifiers' culture. Often, they tell us more about Western
perceptions than about Native cultures—or about the baskets themselves.

As outsiders, we can readily appreciate a basket as a thing of beauty,
because art is a part of all human societies. But a basket is encoded with cul-

Akimel O'odham (Pima)
woman carrying firewood, ca.
1889. Sacaton, Pinal County,
Arizona. (P05927)

tural and personal information, as well. Each basket expresses a subtle dialogue between the individual weaver's creativity and his or, more often, her cultural traditions. Basketmakers, like all artists, follow cultural rules. The continuity of cultural traditions in basketweaving, despite the passage of time and profound social change, is apparent in our ability to identify a basket's cultural (tribal) origin. Within each cultural tradition, individual weavers make choices about design and technique. While tribal rules and traditions give each basket a cultural identity, it is the weaver's imagination and ability that inform her interpretation of cultural rules and give the basket its individual style.

How can we learn to see the Native thought, practice, and aesthetics manifest in historic collections of baskets long removed from the makers and their communities? Since I am not a Native or a weaver, I can only share what I've learned through talking with weavers and researching the baskets in the collections of this museum and other institutions. In addition, because I am not steeped in a single tradition, I have, no doubt, mixed and matched what I have understood. These ideas, though, have been borne out in my research and consultations with Native weavers. This essay, then, presents a system of describing or classifying North American Indian basketry that reflects the way weavers understand baskets. It reflects both my own conversations with weavers and the continuing conversation of weaver to weaver through their art.

> *"The only way to weave a basket is so that your basket moves with your body."*
> —Terrol Johnson

I am indebted to the many weavers who have shared their ideas with me. Pat Courtney Gold (Wasco–Tlingit), Theresa Hoffman (Penobscot), Terrol Johnson (Tohono O'odham), Julia Parker (Pomo), and Lisa Telford (Haida), and scholar Sherrie Smith-Ferri (Dry Creek Pomo), played an important part in helping conceptualize this book and the exhibition *The Language of Baskets: From the Weavers' View*, mounted at the museum's George Gustav Heye Center in New York. Both the book and the exhibition began with the idea that we can understand baskets through the details of their making.

Objects for the exhibition had been preliminarily selected and laid-out when the museum invited Pat, Theresa, Terrol, Julia, Lisa, and Sherrie to a two-day seminar to review the proposed contents and organization. While the basic outline of the exhibition remained constant, these consulting curators sharpened our ideas and choices. Above all, they wished to see more contemporary baskets on view. They wanted to make clear that basketry is a living art, and that the baskets in the museum's collections remain rooted in their cultures, no matter how long ago they were made, used, purchased, and removed from their communities. As the weavers reminded us during our two-day session, basket-makers "have always been and will always be contemporary."

To help illustrate this continuity, the weavers each chose four baskets from the museum's collections and paired them with baskets representing their own or other Native basket-makers' recent work. The juxtapositions of these baskets,

and my Native colleagues' thoughts on what they tell us, are shown in the second section of this book, which follows this essay.

Several years ago, there was a day when I visited Bertha. I had promised that I'd bring along some baskets from the museum. As soon as I crossed the threshold of the door, Bertha exclaimed, "Aunt Nora's basket!" Curious, I asked her how she knew from ten feet away, and before she had even had a chance to hold the basket.

Her reply was deceptively simple. "It just is," she explained. "And she never could put her feathers in straight." As we talked on, I realized she was visually unraveling and re-weaving the basket to understand the choices her Aunt Nora had made fifty years before and the effects she had achieved.

There is an intellectual and artistic replenishment that occurs when Native weavers look at baskets made by their ancestors. Basketweaving is an ancient art form, a continuum in North America several thousand years old. Weavers believe that they work in the present, and that every other weaver does as well—past, present, and future. A weaver's knowledge does not end with her life, any more than it ends when she completes a basket. Her art is a part of the landscape where she harvested her materials; the mountains, animals, and events that shape her designs; and the historic baskets from that world in hundreds of public and private collections throughout North America and Europe. A basket never leaves the maker's culture, because the process it reflects can never be alienated from its roots.

When weavers admire a basket, they do not hold it at arm's length and marvel. Rather, they turn it over to see how it is begun and finished, and look closely to see what materials its maker used and how she used them, her choice of stitching, which designs she chose and how she placed them on the basket's surface. A weaver's critical education begins when she first learns to weave and continues each time she picks up a basket. Techniques and processes are what weavers talk about when they discuss one another's work. And their conversation, like that of all specialists, assumes a certain level of knowledge.

Materials
The weavers I worked with over the years always made me start by watching. Eventually, they would take me along on a trip to harvest materials, because I worked hard, had a truck, and was willing to talk to any outside intruders, like the sheriff, who might happen by.

How can we, as non-Natives and non-weavers, understand how a basket is put together? As Theresa Hoffman explains, "It all begins with a tree in the woods." When a basket-maker admires the quality of another weaver's work, she is commenting on the long and elaborate process of gathering, preparing, and using materials the weaver has learned and mastered. A weaver's ability is dependent upon her adeptness and understanding of her materials. Moreover, in the absence of good materials, and, more critically, properly prepared materials,

good basketweaving suffers. For example, a weaver might look at a basket and comment, "The willow is the wrong color." She is expressing her concern about the disrespectful attitude the maker has shown toward the art of harvesting basket materials by gathering them at the wrong time of year.

The fibers used in basketry come from plants that have been cultivated over many years, and a teacher or family member may leave the bushes or plot of land where she harvested materials to another weaver. Properly harvested and aged sticks produce long sewing strands of even diameter and color. Well-tended plots of sandy soil produce long, straight roots, rather than gnarled, misshapen ones. A weaver inevitably travels through her landscape with a keen eye for climatic conditions that tell her when to harvest and prepare her materials. Basket material cutting time is sacred, and weavers are conscious that they walk where their ancestors have walked.

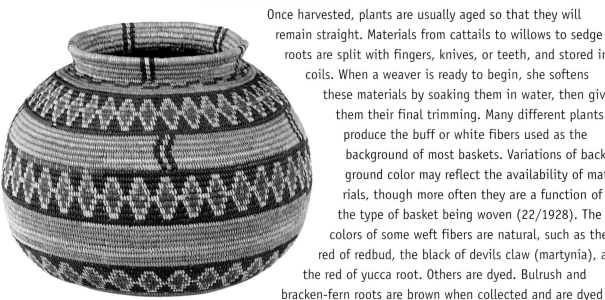

Once harvested, plants are usually aged so that they will remain straight. Materials from cattails to willows to sedge roots are split with fingers, knives, or teeth, and stored in coils. When a weaver is ready to begin, she softens these materials by soaking them in water, then gives them their final trimming. Many different plants produce the buff or white fibers used as the background of most baskets. Variations of background color may reflect the availability of materials, though more often they are a function of the type of basket being woven (22/1928). The colors of some weft fibers are natural, such as the red of redbud, the black of devils claw (martynia), and the red of yucca root. Others are dyed. Bulrush and bracken-fern roots are brown when collected and are dyed black for weaving. Cedar and spruce roots can be lighter or darker depending on the location of the tree, as well as whether the sewing strand is made from the hard outer layer or the softer inner layers. Yucca can be bleached white in the sun.

Gift basket, ca. 1880. Weaver unknown, Panamint Shoshone (Inyo County, California). Two-stick and bundle-coiled willow with split willow and sumac, yucca-root, and martynia stitches. Diam. 14.5 cm., height 10 cm. 22/1928

Some basketmaking traditions have long incorporated new materials. Others suffered as traditional materials became unavailable. All weavers adapted their weaving to the burgeoning tourist trade of the late 19th and early 20th century. Aleut and other basket-makers added brightly colored wool yarn and silk floss to natural basket materials. In the Great Lakes and Prairie regions, Native weavers adapted traditional twining techniques to commercially available cotton string and wool yarn. Because weavers no longer had to harvest and prepare their own raw materials, they invested their time in developing new weaves and patterns with the vibrancy of new colors.

Tools and workplaces

Like all artists, basket-weavers have strong preferences about when and where they work, and the tools they use. Few weavers work full time. Even when baskets were essential containers for cooking and storing food, women wove in the hours when they were not caring for their families in other ways. In communities where men wove, such as the Rio Grande Pueblos, basketmaking came after doing agricultural work and meeting other family and religious obligations. Today, as in the past, friends and relatives get together and weave away the hours and centuries.

Materials are meticulously trimmed to size, and many of the hours a basket-maker spends "weaving" are taken up in preparation. Coiling requires the most precisely trimmed elements. Obsidian blades were once used to trim and scrape plant fibers. Some weavers still prefer volcanic rock or commercial glass blades, although well-worn penknives and kitchen knives are more often seen. Tin can lids punched with holes are also used to size weaving materials. Sewing strands are passed through successively smaller holes until they are uniformly fine.

> *"Even, vibrant color is a sign of carefully chosen materials. The color of redbud is different depending on where it grows. The sticks growing on the south side [of the river] are darker than those growing on the north. One of the rules I was taught is that you wait for it to rain and wash all the dust off the bushes, and then you can really see the colors."*
>
> —Julia Parker

Metal awls, capable of being honed to finer, longer-lasting points, have replaced awls made of bone or cactus spines. Metal awls enabled weavers to make finer baskets, such as those of the Washoe, Panamint Shoshone, and Yosemite Miwok. Basket-makers make awls of knitting needles, screwdrivers, and ice picks, and purchase cobblers' and leather-workers' awls. Each weaver's personal preference determines the length of her awl, the size and type of handle it has, and how it is decorated. A basket-maker may use the same tools throughout a lifetime's work, and they become highly personalized, through use as well as by decoration.

Today, most basket-makers sit at tables to weave. Some work at specially designed workbenches. Others prefer to work sitting on the ground under the shade of a tree, or on the living room sofa in front of the television, or at the kitchen table. The basket might rest on the table, the ground, or the weaver's lap. Weavers use their own bodies as tools, splitting fibers with their teeth or shaping a basket over a knee.

Basket weaves

"Why do you make coiled baskets and not twined ones, like the people over the hills?" I once asked this question of a basket-maker I know, a woman too shy for me to use her name here. She grinned at what I now recognize as my total naiveté.

"It is what we do," she said. "I learned from my mother and grandmother." Then she added, *"I can do everything I need to do with coiled baskets."*

While a weaver might not question her decision to use coiling or twining, she uses the technique in a highly personal way, influenced by cultural tradi-

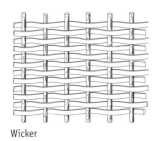

Wicker

Plaiting

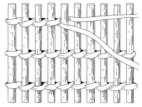

Twining

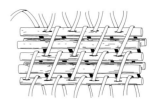

Coiling

3/6798

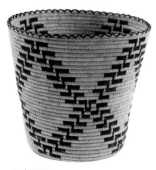

25/5378

Covered storage basket, ca. 1830. Weaver unknown, Wampanoag (New Bedford, Massachusetts). Checker- and wicker-plaited hickory (?) splints with painted decoration. Diam. 50 cm., height 10 cm. 3/6798

Made-for-sale wastebasket, ca. 1970. Weaver unknown, Tohono O'odham (Big Field, Arizona). Bundle-coiled split yucca leaves with yucca and martynia stitches. Diam. 30.5 cm., height 27.5 cm. 25/5378

tions, as well as by the world surrounding her. We can see this clearly through our recognition of individual and family styles of baskets.

Handmade baskets can be either woven or sewn. Woven baskets can be further differentiated into wicker, plaited, and twined types. Sewn baskets are commonly referred to as coiled baskets. To put it another way, wicker, plaiting, twining, and coiling are the four basic techniques used by basket-weavers. All woven baskets are built on a framework or foundation called the warp. The warp may be a bundle of materials, a single shoot or branchlet, or, in the example of miniature baskets, a single fine thread of sewing material. The weft is the material woven around the foundation in and out of the warp. Coiled baskets consist of single or multiple warps or bundles of fibers wound in a spiraling fashion. Each succeeding round is sewn to the previous one.

Most often a single weaving technique is used to create a basket, although weaves are sometimes found in combination, creating varied patterns and textured surfaces (3/6798). Twined baskets often include variations in the specific types of twining used. These variations can be decorative or structural. Most design areas are created by the use of weaves or through the introduction of colored weft or sewing elements. However, a colored material can also be used to enhance the strength and durability or function of the finished basket. For example, the split "horns" of the black martynia seed pods used for the rims of Western Apache, Yavapai, Havasupai, Akimel O'odham (Pima), and Tohono O'odham coiled bowls and trays are a tougher material than the split shoots of willow, sumac, or cottonwood used for the body (25/5378).

Wicker uses a wide or thick, inflexible warp around which a slender, flexible weft is woven. The weaver moves the weft over and under the foundation. Wicker baskets can also be woven with multiple wefts and warps, creating a series of ridges. The wicker technique is often found in combination with plaiting and twined weaving on a single basket. In the Southwest, serving bowls and trays are woven using wicker techniques. At Hopi, *piki* serving trays have wicker borders. The Hopi make hundreds of wicker plaques each year to use in Kachina and Basket Dances (26/1757). Wicker baskets are found less frequently elsewhere. In California they are almost nonexistent except for a few rare Maidu and Pomo examples, and in the Pacific Northwest weavers occasionally weave either wicker bottoms or borders on storage and pack baskets. In the Northeast and Southeast, wicker baskets are commonly made.

The warp and weft in plaited baskets have the same thickness and pliability,

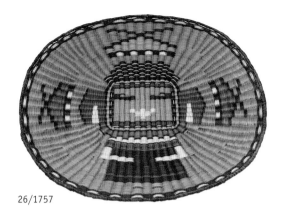

26/1757

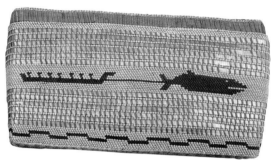

25/1256

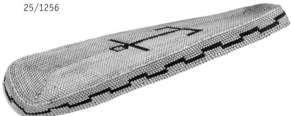

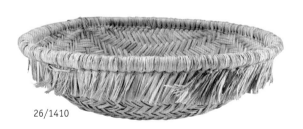

26/1410

Butterfly Maiden plaque, ca. 1970. Weaver unknown, Hopi Pueblo (Arizona). Wicker-plaited dyed peeled sumac or willow shoots; yucca-wrapped rim. Diam. 40.8 cm., height 3.2 cm. 26/1757

Made-for-sale trinket basket and cover, ca. 1900. Weaver unknown, Nuu-chah-nulth (Vancouver Island, British Columbia). Alternating rows of wrap-twined and checker-plaited natural and dyed bear grass on cedar-bark warps. Length 28.5 cm., width 14.5 cm., height 15 cm. 25/1256

Winnowing bowl, ca. 1970. Weaver unknown, Jemez Pueblo (New Mexico). Complex twill-plaited yucca leaves over tamarisk rim. Diam. 15 cm., height 10 cm. 26/1410

and the weaver weaves both elements over and under one another. It is impossible to tell which element is the warp and which is the weft simply by looking at plaiting. Plaiting is also called checkerwork, because of the distinctive surface created by this technique (25/1256). Twilled plaiting is done in much the same way, except that the wefts are woven in pairs, which gives the weave of the finished piece a distinctive diagonal slant. In the Southwest, winnowing baskets, also known as yucca ring baskets, and mats are made by plaiting (26/1410). In the Pacific Northwest, basket bottoms are commonly plaited. The ends of the elements used to plait the basket bottom are then used as the warps for the twined woven body of the basket. Throughout the Northeast and Southeast, plaiting is used by many tribes in different variations to create baskets of many colors, shapes, sizes, and functions.

Twined work uses rigid warp elements woven with two, three, or four flexible weft strands. In the twining technique, the wefts are separated, wrapped around a stationary rod, brought together again, and twisted to lock the stitch in place. The weaver repeats this action over and over until the basket is complete. Subtle, elegant twined patterns are made by changing either the number of wefts (braiding and overlay) or the number of warps (diagonal and two-stick). Wrapped twining is used primarily by West Coast (Makah) and Pomo weavers. The soft-sided woven bags of the Nez Perce and Wasco, and the stiffer walled baskets of the Chinook are also made in the wrapped twine technique. In this technique, one of the weft elements remains inactive on the inside face of the basket, while the active second weft is passed over the warps and this stationary weft.

Twining is the most commonly used of the basic basket techniques in western North America. Any number of twining variations may be found in a single basket. One twined Pomo cooking bowl in this book is begun with three-strand braided twine, which then changes to diagonal twining. In the

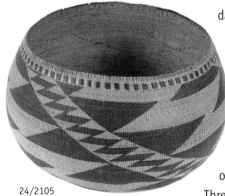

24/2105

Cooking bowl, ca. 1920. Weaver unknown, Central Pomo (central California). Diagonal-twined sedge and redbud over willow foundation. Diam. 36.5 cm., height 22 cm. 24/2105

Basket and cover, ca. 1910. Elizabeth Hickox (1875–1947), Karok (Humboldt County, California). Plain closed-twined willow shoots with half-twist overlay of bear grass and maidenhair-fern stems. Diam. 29 cm., height 22 cm. 16/3589

darker design areas, the weaver used a wrapped twine technique, and at the rim she chose a two-stick or paired-stick twining technique (24/2105). A Tlingit weaver may weave the bottom of a basket using alternating rounds of plaiting and twining, with the remainder of the basket in plain twining and the rim finished in two-stick twining. Using false embroidery—a technique in which the weaver wraps decorative material around the wefts on the outside half of a stitch—a design is created that shows only on the outside of the basket.

Three-strand twining uses three weft elements and is usually confined to starts, finishes, and reinforcing bands. Three-strand twining adds strength to baskets that are to be used to carry heavy loads, and it helps maintain the shape of cooking baskets during hard use. Many Northern California and Great Basin weavers use three-strand twining. In contrast, diagonal twining exhibits a distinctive slant, which is created when the weaver passes the wefts around two warps at a time. After each weft is woven completely around the basket, the pairing of warps is shifted so that no stitch lies directly above any other stitch; thus a swirling or diagonal slant is formed. Weavers from California, Nevada, Arizona, and Utah use diagonal twining. The Pomo weaver Mary Benson made a basket illustrated on page 63 as a prototype for a Smithsonian curator, demonstrating that three-strand twining could be used to make an entire basket rather than just to provide a reinforced start (24/2125).

Beautiful pieces were made by Karok master weaver Elizabeth Hickox (1875–1947) in her own idiosyncratic style (16/3589). Most weavers add or remove warp rods to increase or decrease the size of their baskets. The principle is rather straightforward: the more rods, the more structure to a basket, and therefore the bigger its size. Conversely, when a weaver wishes to decrease the size of her basket, she removes warp rods. Hickox, however, did not remove warp rods from her baskets, but rather decreased the size of the rods themselves in order to constrict the diameter of her baskets.

Coiling begins at the center of the basket bottom and grows in a spiral, with each round attached to the preceding one. The weaver sews the coils together by using an awl to punch holes in the foundation and drawing the sewing strands through them. These strands are single pieces of plant fiber that have been trimmed to a uniform size. Some foundations consist of one, two, three, or sometimes more young, slender plant shoots. Others may be made from bundles of grass or shredded fibers, or from a combination of grass and sticks. Coiled basket designs are made by changing the color of the sewing strand rather than by changing the type of weave, as is done in some twined baskets.

Single-rod coiling involves the sewing of a single element or stick foundation (26/1413). The stitches can be placed to complement one another and create a decorative effect. Baskets made with

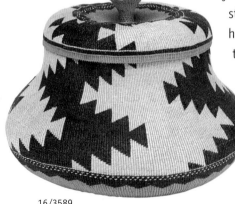

16/3589

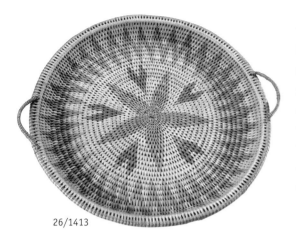

26/1413

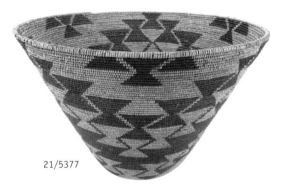

21/5377

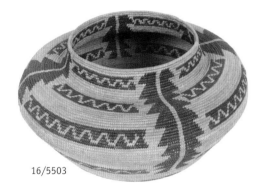

16/5503

Tray, ca. 1965. Weaver unknown, possibly Koyukon (Alaska). One-rod coiled willow shoots with noninterlocking stitches of dyed and natural conifer root. Diam. 42 cm., height 2.5 cm. 26/1413

Cooking or serving bowl, ca. 1920. Weaver unknown, Nisenan Maidu (central California). Three-rod coiled with willow rods and fall and spring redbud stitches. Diam. 53 cm., height 34.5 cm. 21/5377

Shouldered treasure jar, ca. 1910. Weaver unknown, Western Mono (central California). Bundle-coiled deer-grass stems with sedge and bracken-fern stitches. Diam. 25 cm., height 14.5 cm. 16/5503

this technique require less time to construct than three-rod baskets. Because they have less of a foundation, they are not as sturdy as baskets made with other types of coiling, although single-rod coiled baskets can still be watertight. This style of coiling is found throughout the American West. Three-rod coiling (21/5377) uses a bundle of three sticks as the foundation. The sticks are usually arranged in a triangular configuration, which makes it easy for the weaver to stitch only the top stick to the next coil or round. Among some groups, such as the Mescalero Apache and some Ute groups, the three rods are stacked on top of one another. Navajo, Pueblo, and Panamint Shoshone weavers replace the top stick with a softer piece of material, such as a yucca-flower stalk or a grass stem, in order to make it easier to push the awl through the foundation. Today, a Navajo weaver may use from two to eight sticks in the foundation bundle, depending on the size of the basket being woven.

A bundle foundation may consist of shredded plant fibers, grass stems, or specially prepared cattail stems, yucca leaves, or cedar roots. The coils of bundle foundation baskets appear to be round rather than triangular (three-rod) or rectangular (stacked). The Klickitat and Salish use shredded cedar roots; the Yokuts and Western Mono (16/5503) and many other groups in southern central California use grass stems. The Akimel O'odham (Pima) and Tohono O'odham use split cattail stems. And the Hopi use split and shredded yucca leaves.

The weave a basket-maker uses is a cultural choice, governed by time-honored tribal traditions. It is not a decision she makes individually, but rather one governed by the social setting in which she lives. When a Pomo woman makes a cooking bowl, for example, it will be twined, while a neighboring tribe, the Patwin, primarily made coiled cooking baskets. Moreover, specific types of twining differentiate the various sub-groups of the Pomo, such as the Central, Southwestern or Kashaya, and Lake Pomo. The four weave types and their variations help with the determination of a basket's tribal origin. Even so, there is still an individual hand discernible in each basket. The use of wicker, plaiting, twining, and coiling does not dictate a basket's shape, decoration, size, or function.

Interestingly, the same four basket weaves are found around the world. Nonetheless, where a basket was made can always be identified. Plaited baskets from the Philippines can look deceivingly like plaited baskets from the southeastern United States—

until, that is, you truly look at them and take note of their particularities of materials, rim finishes, and design.

Starts and finishes

Historically, within a culture, a certain kind of basket is started in a characteristic way, and variations in basket starts carry cultural information. Pomo weavers use seven different starts in their coiled work and at least ten in their twined ware. Makah basket-makers start their baskets with a plaited base, but then twine the baskets' sides. Square and rectangular plaited baskets are usually begun with a checker- or twill-plaited base. Round plaited baskets are usually begun with a radial start where the warps are laid down like the spokes of a wheel, though that may be the only design elements these baskets share.

Finishes are more varied, and often the finish begins well before the last row or two of stitches. It may be a wide band, where the weave or pattern changes. It may be a few rows of solid color, or of ticking or alternating colors. Finishes fit the intended use of a basket. Those made for hard work have sturdy, reinforced rims and finishes, while baskets made for sale or display can have more fanciful decorative finishes. The type, color, and technique of finishes can also be culturally appropriate, such as the extra row of wrapping applied to Choctaw baskets or the solid black binding of White Mountain Apache baskets.

Splices and workfaces

Before looking at a basket and suggesting that it was made clockwise or counterclockwise, the viewer must consider which side of the weaving faced the weaver—usually the neater surface. Two basketry bowls can resemble each other in every detail, but be woven in opposite directions. Haida and Tlingit baskets seem to be woven in the same way, but in this case appearance is deceiving: Haida women work with the basket upside down. In twining flat trays, the weaver must constantly change the workface to keep the work direction and twists uniform. When this is not done, the stitches form V's— an unusual and distinctive method used by only a few cultures.

The Ohlone tray (5/786) is rare because it survived the devastation of Ohlone people more than 225 years ago, but also because it is the only twining in North America where the weaver works back and forth across one surface, rather than turning the piece over in order always to be working in one direction.

All types of basketry require the weaver to make splices when a weft color changes or a sewing thread gets too short. Strands can be wrapped around each other or caught under adjacent stitches. In twining, warp rods are added or subtracted to change the diameter of a basket, their ends chewed or trimmed and stuck between existing warps. Sewing thread may be trimmed on the inside or outside surface of a basket, or hidden in the foundation bundle. Threads may be left long and caught under succeeding stitches, trimmed flush with the sur-

Winnowing tray, ca. 1780. Weaver unknown, Ohlone (Monterey County, California). Diagonal-twined sedge and equisetum root. Length 43.5 cm., width 26 cm., height 12 cm. 5/786

face, or finished as slight protrusions or nubs. Within cultures, rules concerning the treatment of ends are so strictly followed that this detail can be used to help identify baskets.

Shape

The forms of most baskets announce their function. There is nothing ambiguous about the shape of a burden basket, or a basketry scoop or tray. Shape does not necessarily dictate weaving technique, as different weaves can be used to create similar forms. Large Apache jars have a characteristic silhouette, as do Thompson River Salish trunks, and whaler's hats made by the Nuu-chah-nulth. Basket-makers work within these cultural parameters—or depart from them, as in the case of the Tlingit hat design adopted from the Russian Navy (p. 68, 16/5272).

Many traditional baskets and therefore shapes were reduced in size for sale to non-Indians. While a made-for-sale tray may still be identifiable as a tray, its size precludes its use for anything other than decoration. Other shapes may be adapted from another tribe's repertoire in order to emulate types of baskets successfully sold to non-Indians. As traditional economies and foods were increasingly replaced by introduced crops, livestock, and store-bought items, the use of baskets faded. They were no longer needed to harvest, prepare, cook, and serve food.

> *"My family and I always say that when you weave a basket, it brings out your personality. And you can see those ladies were happy, with all the colors and patterns, and that they cared about every stitch that they put in, and they didn't count the stitches."*
>
> —Julia Parker

Regardless of the maker's weaving ability, a basket made of improperly prepared materials will have uneven stitches and designs, and may warp, split, or twist with time. A basket that has kept its shape over many years testifies to the sum of its maker's skills.

Design field

In theory, the entire surface of a basket can be covered with designs, but different weavers consider different areas, such as the bottom or the rim, unsuitable for decoration. The rim or shoulder of a basket may be decorated differently from the body. A weaver may use wide spacing or small, isolated design elements to delineate a basket's design field, or she may frame the field with border bands. Design elements that are used by many different tribes can often be distinguished by their placement within the design field. Two groups may use the same design, but one may orient it in a more upright way than its neighbor. During the early part of the 20th century, non-Indian buyers requested more realistic birds and other naturalistic representations on baskets. Weavers complied by reducing the amount of abstracted iconography, as well as by simplifying design layout and complexity.

Understanding a basket's use can often help make sense of the basket-maker's decisions about design field. The side of a burden basket that is worn against the back, for example, often has a very different design from the side

that faces out. A basket made to be worn on a belt may have a design that looks best when seen from above.

The Weaver's Aesthetic

It took many visits before she ever agreed to show me how she wove her baskets. Maybe she was more interested in eating pie and talking, finding out why this non-Indian wanted to know about baskets. Within the year, I was driving her everywhere. I even convinced her to demonstrate basketmaking at a local gallery. Nonetheless, we discussed her own weaving perfunctorily, while we spent hours discussing every other known weaver's work.

As we traveled together, I noticed that I was increasingly called upon to be the spokesperson, to explain her weaving and comment on the numerous baskets that were shown to us. I was happy to do so. For her, being a basket-maker was inseparable from the individuality she proudly carried, and from her community and family, not a certificate of expertise.

Regardless of the time we spent talking and traveling together, she never once commented on what I thought I knew about baskets, but rather, through a raised eyebrow or question, she turned my attention to the details of basketmaking.

> "For us, even a birchbark canoe is a big basket."
> —Theresa Hoffman

Many of my questions were met with silence. I grew used to my ignorance, but never comfortable with prying. Then, while visiting the wintery cold of a museum's storage space to look at baskets, she sat me down to answer a question I had asked about a year earlier. She was good and ready to talk, and she spent three hours answering what I had believed to be a simple question.

Using basket technology to understand the aesthetics of baskets as weavers do teaches us to look beyond the finished piece to the process of weaving—the context of its creation. Native cultures are vital and ongoing, strengthened by change and adaptation. Understanding basketmaking as process offers us a means to see the interrelation of conception, creation, and expression.

Too often, when people think about Native American baskets, we assume that the weavers who make them are hemmed in by rules that govern the "traditional" arts. Nothing could be further from the truth. Tradition is not a list of rules, but rather a set of values that guide the weaver's work. Tradition may tell her to use plain twining to make a winnowing basket, but it also allows her to create a masterpiece, different from every other winnowing tray.

Of course, this is not true simply of baskets, or of Native American art. Painters are bound by the idea of what a painting is, as well as by conventions of creating light, space, and dimensionality on a flat surface. Values change, so European art history has realists, impressionists, and modernists, but they are all painters using color and surface. Basket-weavers, too, are artists who use tools and values to create new worlds. Basketry excelled as it was transformed by new ideas, materials, and tools introduced by non-Natives. Baskets in the Northeast changed from twined to plaited as European-American settlement

23/2167

rendered traditional Native farming and hunting practices impractical. Other groups developed new design repertories and iconography to reflect the intermingling of Native populations or contact with European-Americans. Weavers found inspiration in other tribes' work, new basket functions dictated by new farming and household activities, and the opportunity to tell tourists and others about their cultures (23/2167).

Many of the treasures in the museum's collections reflect this dynamic. The Chumash tray decorated with a Spanish coin motif, for example, was commissioned nearly two hundred years ago by Spanish administrators in Monterey, California, as a gift for a visiting dignitary (23/132). One thing that strikes me about its history is that the Chumash, who lived near Santa Barbara, were so well known for their basketmaking that they would receive a commission from the colonial capital, 250 miles away.

This essay explores what weavers, not historians or curators, can teach us about Native basketmaking, and that brings a second example to mind. Another remarkable piece in the museum's collections is a small basket made by the Eastern Pomo weaver William Benson (p. 64, 24/2106). Curatorial records show that Benson told Grace Nicholson, the Pasadena basket dealer and collector who represented Benson and his wife, that it was the first basket he ever made, and that he wanted Nicholson to have it as a gift. Coming upon this basket and story as they consulted on this exhibition, my weaver colleagues could only smile, confirming my own suspicions. There is no way this basket could be anyone's first effort, they pointed out. It took a great deal of skill to prepare the sedge root and weave it with silk thread.

Understanding structure and technique is, of course, different from understanding creativity. Technical skill, and even the complicated process of coordinating materials, weave, shape, design, and function is only a part of a weaver's competence. Yet a process-oriented view of basketry can help us find the beauty and meaning in baskets as weavers themselves do, in the creation of their art.

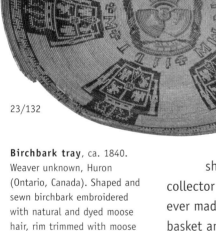

23/132

Birchbark tray, ca. 1840. Weaver unknown, Huron (Ontario, Canada). Shaped and sewn birchbark embroidered with natural and dyed moose hair, rim trimmed with moose hair and cotton thread. Length 23.5 cm., width 20 cm. 23/2167

Presentation tray, ca. 1825. Juana Basilia Sitmelelene (1780–1838), Chumash (Santa Barbara, California). Bundle-coiled juncus stems with natural and dyed juncus stitches. Diam. 48 cm., height 8.5 cm. 23/132

From the Weavers' View

In spring 2003, the museum invited five Native basket-makers and one Native basketry scholar to a two-day seminar to review this material in its early stages. All of them expressed the wish to see basketry presented as a living art, with strong links to cultural history. To help illustrate this continuity, each weaver chose baskets from the museum's collections and paired them with baskets from his or her own and other contemporary basket-makers' works.

Lisa Telford

"When I was young, I was obsessed with math and divisions. I saw one of my grandmother's old baskets and I sat down and counted every stitch. At first my basketry had to be perfect, and then I let it all go and that's when I found true joy."

Lisa Telford was born in Ketchikan, Alaska, and now lives in Old Massett, British Columbia. She learned basketweaving from her aunt, the well-known Haida basket-maker Delores Churchill. Lisa, who makes cedar-bark baskets and cedar-bark clothing, has participated in exhibitions in Washington, Arizona, California, New Mexico, and Alaska, and has received numerous honors, including serving as an artist-in-residence at the Eiteljorg Museum in Indianapolis and the National Museum of the American Indian. She compares making baskets to therapy, saying it helps her relax from the stresses of life.

You can't get over how exquisite these baskets are. To touch something that's so very beautiful, so fine, that someone made a hundred years ago—knowing they just made them and sold them for nothing—is the experience of a lifetime.

When I was thirteen years old, my grandmother wanted to teach me how to weave. Haidas never said, "I want to teach you how to weave." They said, "Come here, I want to show you something." But I was thirteen, and when

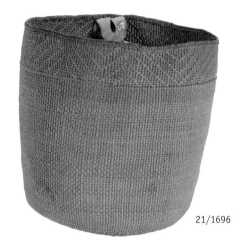

21/1696

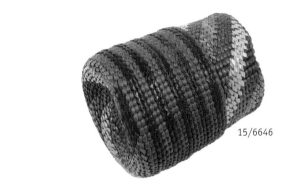

15/6646

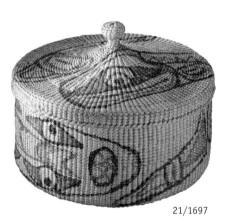

21/1697

you're thirteen you don't have time to do that kind of thing. My grandmother passed away in 1982 and she always wanted to show me, and I missed the opportunity. Instead, a few years later I got hooked up with my aunt, who came and gave me my first lesson and some scraps of bark. From that I made a sorrowful hat and was very proud of it. I moved on from there and just worked on my own.

There are twenty Haida speakers remaining in the world today, and my mother is one of them. She's teaching my granddaughter to speak Haida, and now is the time. My granddaughter can sing Haida songs, and she's learning how to do basketry. The only thing she doesn't know how to do is start a basket. She'll ask, "Can I weave on your basket?" And I'll say, "No, start your own." She'll say, "I can't." So I'll start it for her. The next step for her is to start one on her own.

When I looked at this small berry basket I saw my mother running with it as a child (21/1696). Basketry was an everyday part of her life. My mother's grandmother, Elizabeth Stanley, would weave small baskets with a loop on two sides for picking berries. A string made of rags would be attached to hang around my mother's neck. At the end of berry season my mother would play with the basket, filling it with junk until it was no more.

I like small things, and I like the black bands done in false embroidery on this basket (15/6646). These pouches would hang off a belt and hold snuff.

Berry-picking basket, ca. 1900. Weaver unknown, Haida (Vancouver Island, British Columbia). Plain and diagonal closed-twined spruce root. Diam. 12 cm., height 13.5 cm. 21/1696

Snuff container, ca. 1920. Weaver unknown, Tlingit (Alaska). Plain closed-twined spruce root, false embroidered with natural and dyed bear grass. Diam. 5 cm., height 6.5 cm. 15/6646

Covered bowl, ca. 1900. Weaver unknown, Haida. (Queen Charlotte Islands, Canada [?]). Closed-twined spruce root with painted decoration. Diam. 8.5 cm., height 5 cm. 21/1697

Souvenir basket, ca. 1890. Weaver unknown, Tsimshian (Metlakatla, Alaska). Plain closed-twined spruce root, false embroidered with maidenhair-fern stem and canary grass. Diam. 11.5 cm., height 9 cm. 24/7216

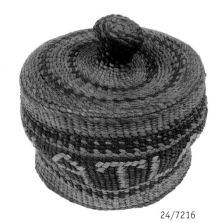

24/7216

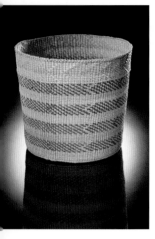

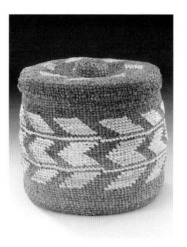
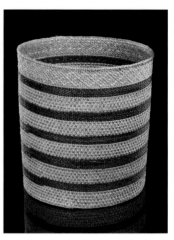

26/1697 26/2576 26/2613 26/2705

Miniature basket, 2003.
Isabel Rorick, Haida (Hornby
Island, British Columbia).
Plain and diagonal closed-
twined natural and dyed spruce
root. Diam. 9 cm., height 8 cm.
26/1697

Shot pouch and cover, 2003.
Teri Rofkar, Tlingit (Sitka,
Alaska). Plain closed-twined
spruce root, false embroidered
with maidenhair fern and canary
grass. Diam. 5 cm., height
4.8 cm. 26/2576

Rattle-top lid basket, 2003.
Loa Ryan, Tsimshian
(Bremerton, Washington).
Closed-twined red cedar bark,
false embroidered with canary
grass. Diam. 18 cm., height
17.5 cm. 26/2613

Black-banded basket, 2003.
Lisa Telford (b. 1957), Haida
(Everett, Washington). Plain
closed-twined natural and dyed
spruce root. Diam. 51.3 cm.,
height 28.5 cm. 26/2705

One part of the basket telescopes into the other to keep the contents safe. This kind of basket reveals itself, and as it does I often notice that the interior is more beautiful than the exterior. The top of the pouch design is called fern fronds, because when the fern is beginning to bloom it swirls open. The spruce roots on the interior are dyed green. Strands of natural and orange-dyed grass are used to create a spiral design on the side.

The spruce roots for this basket were carefully dug (21/1697). The quality and fineness of the weaving in this basket are rarely seen in baskets today. After all the work to complete this basket, the painted form lines are not clean and crisp, the design not completely clear. It seems the grandmother wove it and passed it to an adored grandchild, who could do no wrong, to adorn. To complete this basket would take ninety hours of weaving for me, not counting the digging, peeling, splitting, and preparation of the roots.

I wanted to represent the Northwest as well as possible, so I selected this Tsimshian basket (24/7216). I really enjoy seeing baskets with writing on them. Metlakatla is the name of a Tsimshian village, a place where baskets are always done in red cedar bark and started with a knot. The color change on the basket is probably alder-bark dye, which creates brown.

My cousin Isabel Rorick learned to weave from my grandmother Selina Peratrovich. I selected Isabel's basket because she is one of the finest weavers alive today (26/1697).

Teri Rofkar creates no more than forty baskets a year, and each one is exceptional (26/2576). Teri is one of a handful of weavers who continue the tradition of spruce-root weaving. With an abundance of cedar bark at her fingers, Teri takes a skiff out on the ocean and searches for spruce roots near the shoreline.

Loa Ryan is from old Metlakatla. She still weaves with red cedar bark (26/2613). Most weavers from Metlakatla prefer to use yellow cedar bark, since the stitches are smoother. Weaving with red cedar bark and having it look good takes years of practice, and Loa has this process down.

Pat Courtney Gold

"Our people were moved from a traditional place to reservations, and during that move we lost a lot of our culture. We lost variation, skills, especially in basketry, and it took a hundred years to get them back. So there is some pain there for us."

Pat Courtney Gold is enrolled in the Wasco Nation of the Warm Springs Confederacy. After pursuing a career in math and computer science, in the early 1990s she turned her attention to basketmaking. Since then, she has exhibited her baskets throughout the United States and has curated several basketry shows. Harvard University's Peabody Museum recently commissioned her to write an essay on the Wasco basket collected by the Lewis and Clark Expedition in 1805 and to create a contemporary Wasco basket for the Peabody's collection. Pat seeks to preserve basketry techniques and traditional designs unique to the Columbia River area. "I enjoy experimenting with new fibers and trying variations on old designs," she explains. "I'm sure if my ancestor basket-weavers were transplanted into this century, they would be inspired to do the same."

Native art cannot be separated from culture and tradition. Historically, commerce and trade were very important among the people along the Columbia River. The rivers connected all the nations who used canoes, much as we use cars to travel the highways. The trade center, Nixluidix, a Wasco–Wishram town, was very much like our shopping malls. Baskets were used to collect, store, and trade food items. The baskets were made to standard sizes, roughly equal to pint, quart, gallon, and two-gallon volumes, so that trade goods like pemmican, berries, wapato tubers, camas bulbs, and bitterroots could be measured. Even today, baskets are used for root and food gathering, storage of dried foods and personal items, and as gifts at festivals and give-aways.

Many basketry images represented the environment—salmon, sturgeon, people, condor, mountains, and water. Abstract images include sturgeon roe, fawn spots, and salmon gills. Traditional designs are handed down from family to family and sometimes from tribal nation to weavers. Native elders are living museums. They pass on the weaving traditions, techniques, and designs. The twined cornhusk bag with geometric images, the Klikitat coiled basket with its traditional shape, and the cedar-bark and sedge-grass Chinook basket are beautiful examples of the continuation of 12,000 years of Native heritage.

A lot of our baskets tell stories. This basket tells of a mother leading a little child on a horse (13/8647). Each horse is different; one has spots like an Appaloosa. The family is going into the woods in the Columbia Gorge, where there are deer and condors.

Sally bag. ca. 1890. Weaver unknown, Wasco (Washington). Closed wrap-twined rushes and cornhusk over cattail-string foundation, with leather rim and carrying straps. Diam. 23 cm., height 23.5 cm. 13/8647

Pouch, ca. 1930. Weaver unknown, Clatsop (Oregon). Closed-twined hemp, false embroidered with bear grass and cherry bark. Length 15.5 cm., width 10.5 cm. 22/4544

Sally bag, ca. 1900. Weaver unknown, Wasco (Washington). Closed wrap-twined natural and dyed rushes over hemp foundation, with cotton velveteen rim. Diam. 18.5 cm., height 17.5 cm. 13/8644

Sally bag, ca. 1915. Weaver unknown, Wasco (Washington). Closed wrap-twined natural and dyed rushes over rush-cordage foundation, with leather rim. Diam. 16 cm., height 16 cm. 13/8654

Covered basket, 2003. Frances "Millie" Lagergren, Chinook (Grand Ronde, Oregon). Bundle-coiled grass with natural and dyed raffia stitches. Diam. 20 cm., height 18 cm. 26/2612

Sally bag, 2003. Pat Courtney Gold, Wasco–Tlingit (Scappoose, Oregon). Closed wrap-twined acrylic yarn over Hungarian hemp foundation. Diam. 15.5 cm., height 26.5 cm. 26/2617

Hat, 2003. Jenny Williams, Nez Perce (Pendleton, Oregon). Closed wrap-twined cornhusk and wool yarn over hemp cordage foundation, with cotton cloth lining and leather rim. Diam. 17.5 cm., height 17 cm. 26/2639

Berrying basket, 2003. Nettie Jackson, Klikitat (Washington). Bundle-coiled conifer root with conifer-root stitches and imbricated design of bear grass and cherry bark. Diam. 20.5 cm., height 26 cm. 26/1611

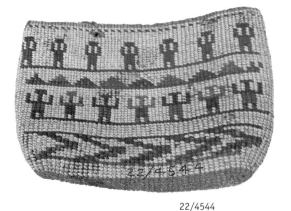
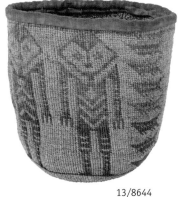

22/4544

13/8644

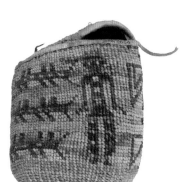
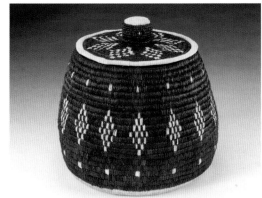

13/8654

26/2612

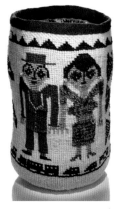

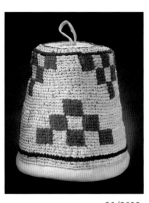
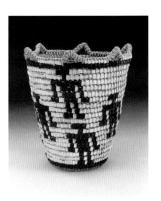

26/2617

26/2639

26/1611

I like this basket because it's so typical of women when they're dancing (22/4544). The traditional dress has very wide sleeves. When you're dancing and moving, you usually move your arms, so it looks like you have wings.

I recognize the weaver who made this bag (13/8644). I don't know her name, but I've been in enough museums and studied enough baskets that I recognize her figures, the quality of her work, and her use of color.

I made "Yuppie Couple" using the traditional twining technique, but the geometric human images reflect the new urban Native (26/2617).

Julia Parker & Sherrie Smith-Ferri

"You follow the rules, and just relax, let those pieces of fiber in that basket just dance in your hands."

Julia Parker was born in 1929 in Graton, California, and educated at Bureau of Indian Affairs boarding schools. Julia learned to weave from her husband's grandmother, Lucy Telles, a Mono Lake Paiute artist who worked as a cultural specialist at the Yosemite Museum, a position Julia now holds. Julia continued her studies with local Miwok–Paiute weavers Carrie Bethel, Minnie Mike, and Ida Bishop, and later studied Pomo basketry with master weaver Elsie Allen and several other teachers. Through her classes and demonstrations at Yosemite and in many elementary schools, colleges, and museums, Parker plays an important part in preserving the games, tools, and foods of California Indians, as well as their basketry.

Sherrie Smith-Ferri, director of the Grace Hudson Museum in Ukiah, California, grew up in Sonoma County, in a Dry Creek Pomo and Bodega Bay Miwok family. Sherrie's grandmother, Lucy Smith, learned basketmaking in the early 1900s, when she was young. She returned to the art in her 60s, after her children were grown. "I learned as a child—and don't question to this day—the truism that Pomo Indians made the best baskets in the world," Sherrie confesses. The Pomo baskets in collections throughout the United States and Europe led Sherrie to see basketmaking and collecting as a rich field for academic study. "The basketry market at the turn of the 20th century was a crossroads, a place where Native women could get together and make a living when few other options were open to them, and one of the few places where Natives and non-Natives met to negotiate issues of cultural identity."

We selected four older pieces from the museum's collections to illustrate the excellence and diversity of Pomo baskets made by weavers nearly a century ago. These baskets were the creations of gifted artists—women of talent, discipline, and experience. They combined technique, design, shape, and quality materials to produce extraordinary pieces that sing and beckon and shine. The contemporary baskets displayed here demonstrate how Pomo basketry has both endured and changed. The work of Pomo weavers today is smaller, and baskets are generally coiled, rather than twined. Baskets are made for new purposes, and yet their origin is still the earth. Weaving enmeshes you in older, traditional relationships. As Julia says, "You take from the earth and say please, and you give back to the earth and say thank you. You feel the spirits all around you, you just feel good, and then you say a prayer."

Today, rather than weaving for the market, Pomo weavers usually create baskets for personal and cultural reasons. Often baskets are made as presents for special people and to mark important events. Enjoy the beauty of these pieces. They are close to our hearts.

Twined trays made from whole shoots like this look deceptively simple and are endlessly useful (24/4117). They have their own plain beauty.

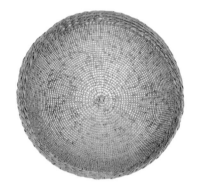

24/4117

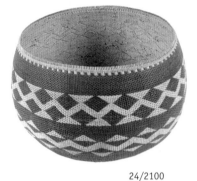

24/2100

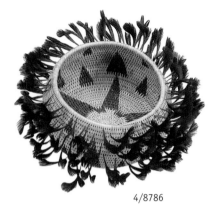

4/8786

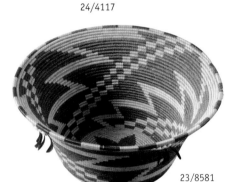

23/8581

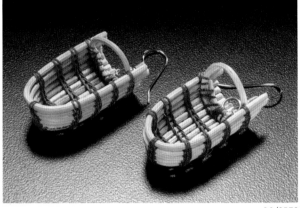

26/2573

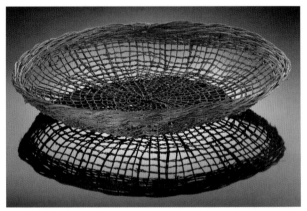

26/2687

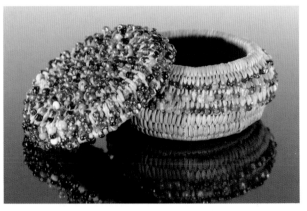

26/2688

Work tray, ca. 1930. Weaver unknown, Pomo (central California). Open plain-twined hazel shoots. Diam. 33.5 cm., height 7.6 cm. 24/4117

Cooking bowl, ca. 1910. Attributed to Mary Benson (1878–1930), Central Pomo (Yokaya, California). Closed plain-, diagonal-, and wrap-twined willow and peeled and unpeeled redbud. Diam. 24 cm., height 15.5 cm. 24/2100

Gift basket, 1925. Weaver unknown, Pomo (central California). One-rod coiled willow with sedge-root and bracken-fern-root stitches and added quail topknot feathers. Diam. 16.5 cm., height 7 cm. 4/8786

Bowl, ca. 1900. Weaver unknown, Pomo (central California). Three-rod coiled wil-low with sedge-root and bul-rush-root stitches; applied shell beads and quail topknot feath-ers. Diam. 30 cm., height 14 cm. 23/8581

Baby-cradle earrings, 2003. Christine Hamilton (b. 1947), Yokayo Pomo (Mendocino County, California). Open-twined willow and cotton thread. Length 2 cm., height 3 cm. 26/2573

Work tray, 2003. Lucy Parker (b. 1953), Yosemite Paiute–Coast Miwok–Mono Lake Paiute–Kashaya Pomo (Lee Vining, California). Open, plain-twined unpeeled willow. Diam. 54 cm., height 28.5 cm. 26/2687

Beaded miniature basket, 2003. Julia Parker (b. 1929), Kashaya Pomo–Coast Miwok (Yosemite, California). Three-rod and one-rod coiled willow and sedge root with glass beads. Diam. 12 cm., height 38.6 cm. 26/2688

The weaver reversed the normal color scheme in this basket, using the rich mahogany-hued redbud as her main design field (24/2100). The even, vibrant color demonstrates the care she took in choosing her materials.

The shape of this basket is very satisfying, and its design enhances that shape (4/8786). Notice, too, the separate pattern on its bottom, known to the weaver but usually hidden from view.

We chose this basket because it is fun (23/8581). We couldn't leave it in storage, just sitting there on the shelf. When you shake it, the little feathers shimmer and say, "Hi, look at me!"

These miniature baby-basket earrings are a popular new phenomenon in Pomo country (26/2573). However different in size and materials, they remain true in shape and technique to their full-size original model.

Terrol Johnson

"Coming into the presence of these baskets, chills go down your spine. You're looking at hundreds and hundreds of years of work."

Terrol Johnson, co-director of Tohono O'odham Community Action (TOCA) in Sells, Arizona, divides his time between working as an artist, organizing basketry initiatives, including a basketry cooperative, and conducting educational outreach programs for youth. He credits his grandfather, a traditional healer, with encouraging his sense of community spirit, which he describes as "the desert people's way."

Terrol's art combines a variety of traditional and contemporary techniques and has earned awards throughout the Southwest. "It reflects my connection to tradition as well as the diversity of contemporary life," he says. "It walks in two worlds."

The Tohono O'odham—People of the Desert—have always lived in tune with our surroundings. Our culture and our very survival have depended upon that ability, and this closeness to the physical world around us is reflected in our basketry. In the Sonoran Desert, the *ha:sañ*, giant saguaro cactus, stands over the landscape. My people consider the ha:sañ to be one of our relatives and holy to us as a people.

Just as today's world is reflected in the work of contemporary weavers, historic weavers reflected their world in these baskets. Until the 1930s, willow and cattail were the primary materials used in our baskets. Then farming surrounded the reservations, and the water table dropped. The willow trees and cattails that were once abundant in the lower parts of the desert are no longer there. So weavers moved on to an alternative material, the yucca, which you now often see in O'odham baskets. Our ever-changing environment has inspired generations of contemporary weavers. We find ourselves in a world in which tradition is still very much a part of our contemporary lives, and our heritage is central to our contemporary identity.

Bowl, ca. 1920. Weaver unknown, Akimel O'odham (southern Arizona). Bundle-coiled cattail with cottonwood and martynia stitches. Diam. 12.3 cm., height 12.5 cm. 10/8171

Made-for-sale basket, ca. 1920. Weaver unknown, Akimel O'odham (southern Arizona). Bundle-coiled willow with natural and dyed willow and martynia stitches. Width 11.5 cm., height 30 cm. 12/324

Tray, 2003. Sadie Marks, Hopi Pueblo (Sells, Arizona). Bundle-coiled bear grass with natural and sun-bleached yucca, yucca root, and martynia stitches. Diam. 55 cm., height 12 cm. 26/2616

Miniature bowl, 2003. Lola Thomas, Tohono O'odham (Chui Chui, Arizona). Bundle-coiled yucca with willow and martynia stitches. Diam. 11.5 cm., height 4 cm. 26/2614

Tray, 2003. Virginia Lopez, Tohono O'odham (Sells, Arizona). Bundle-coiled bear grass with yucca and martynia stitches. Diam. 71 cm., height 10 cm. 26/2615

Tray, ca. 1970. Isadora Rios, Tohono O'odham (southern Arizona). Bundle-coiled cattail with yucca and martynia stitches. Diam. 30 cm., height 3.4 cm. 26/1777

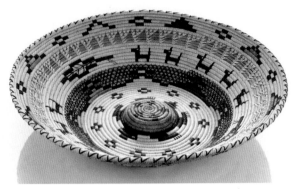

26/2616

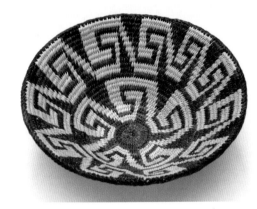

26/2614

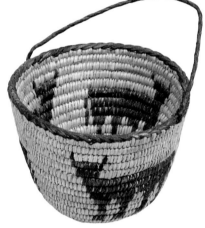

10/8171

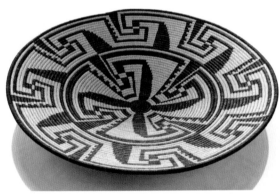

26/2615

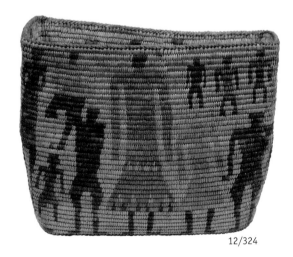

12/324

26/1777

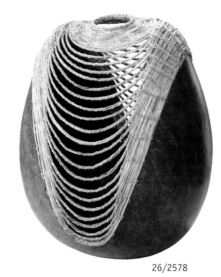

26/2578

26/163

Basket, 2003. Terrol Johnson, Tohono O'odham (Tucson, Arizona). Cast-bronze gourd with bundle-coiled bear grass. Diam. 21 cm., height 25 cm. 26/2578

Basket, ca. 1970. Weaver unknown, Tohono O'odham (southern Arizona). Bundle-coiled cattails with natural and sun-bleached yucca, yucca root, and martynia stitches. Diam. 28.9 cm., height 35.3 cm. 26/163

Clearly the weaver of this small basket lived and worked near a cattle ranch or open range (10/8171). She was illustrating an everyday scene in a whimsical way. But this also reflects the changing environment of my people: cattle were introduced by Spanish missionaries.

The design on this folder basket is not at all traditional (12/324). To me, it tells the story of a journey. Maybe the weaver traveled to Tucson to sell her baskets to tourists passing through at the train station. Perhaps watching the crowd as they got on and off the train inspired her to create this basket. I see a family walking down the platform and someone running to catch a train. I see a couple hugging each other as they say goodbye.

Sadie Marks's work represents a trend in Native culture (26/2616). Sadie is a Hopi from Second Mesa, but she learned to weave from her Tohono O'odham mother-in-law. This mixing is common today. Many Native people have met at government boarding schools and intertribal gatherings. Sadie's baskets combine Tohono O'odham and Hopi styles and techniques with her own inspiration.

Lola Thomas's stunning basket is made with traditional techniques, but uses less willow and cattail (26/2614). Lola's miniature baskets reflect the reality of scarce resources. Even so, they are as fine and complex as their full-size cousins. That's what I want people to see when they look at Lola's work side-by-side with Virginia Lopez's basket (26/2615).

As I have traveled to museums, art shows, and galleries across the country, I have been inspired by other Native and non-Native artists. My environment is filled with both traditional media and new media. This piece represents an evolution in my own work (26/2578). I started by weaving traditional baskets. A few years ago, I decided to apply traditional techniques in new ways by weaving on top of gourds. This piece takes that approach a step further. I cast a large gourd in bronze, worked to get a nice patina, then wove on top of the bronze using traditional basketry materials. It reflects my connection to tradition as well as the diversity of contemporary life. This piece walks in two worlds, just as many Native people do.

In June or July we go out and we harvest *bahidaj*, saguaro fruit. This fruit is made into a sacred wine during the Jujkida, the Rain Ceremony, which brings the monsoon rains. It is an activity that was central to the life of the weaver when this basket was woven decades ago, and it is as central to my life today (26/163).

Dust devils are a common sight during the saguaro harvest. The spinning and twisting funnels of dust wander across the desert floor. Here a weaver depicts this swirling motion in basketry form (26/1777).

Theresa Hoffman

"It all begins with a tree in the woods."

Theresa Hoffman, a Penobscot fancy basket-maker, apprenticed with the late Madeline Shay. A strong advocate of Wabanaki basketmaking—she still uses molds and blocks handed down from her great-grandmother—Theresa is executive director and a founding member of the Maine Indian Basketmakers Alliance. "I first became aware that after hundreds, perhaps thousands of years, our knowledge of basketmaking was slipping away," she says. "I was one of only a dozen Maine Natives under the age of fifty who were making ash and sweet-grass baskets. When Madeline, the last fluent speaker of the Penobscot language, died, I became determined not to watch traditional basketmaking die as well."

From Creation to pack baskets, woven with curved bellies to fit in the sides of our birchbark canoes, to fancy Victorian art pieces, to potato baskets for the harvest in Aroostook County, Maine Indian baskets have embodied a way of life and identified us as Woodland people. Baskets appear in our stories of the Wabanaki culture hero Glooskap, who helped make human life possible. The story told by Mary Sepsis (Passamaquoddy), translated and published in 1884, says, "Glooskap came first of all into this country . . . into the land of the Wabanaki, next to sunrise. . . . And in this way, he made man: he took his bow and arrows and shot at trees, the basket-trees, the Ash. Then Indians came out of the bark of the Ash-trees."

I remember a colleague purchasing a brown ash model biplane made by eighty-year-old Lola Sockabasin, a Passamaquoddy basket-maker, and asking me, "Is that contemporary?" I said, "Yes, we have always been contemporary. There will be more basket-makers after us, and they will be contemporary, too."

This Abenaki velvet-lined, open purse basket is classic Victorian, made for sale to summer visitors to Maine, New York, or Canada (11/6999). The ash and sweet-grass tassels and woven lace made from an ash log remind me that ash is the silk of the basket woods.

The miniature pack basket represents the other end of the spectrum—function and form, a basket to sustain our life of hunting and fishing and traveling the rivers to the ancient coastal summering grounds (8/7381).

The Passamaquoddy birchbark wall pocket is likely almost identical to one at Campobello Island where Franklin Roosevelt, a collector of Tomah Joseph's work, summered. Showing Passamaquoddy artistry, life, and rich storytelling in bark is a very old language in North America (10/4353).

The Penobscot covered basket is an unusual piece, perhaps made for keeping kitchen or picnic supplies (22/1345). The diamond weave is classic, and the cover shows our connection to the world around us—flowers made of wood.

Fancy dish with handles, 1910. Weaver unknown, St. Francis Abenaki (Odanak, Quebec). Checker- and wicker-plaited black-ash splints with lace-weave and silk ribbon trim, braided sweet-grass handles, and velveteen lining. 11/6999

Miniature pack basket, ca. 1915. Weaver unknown, Penobscot (Old Town, Maine). Wicker-plaited black-ash splints. Width 10.5 cm., height 12 cm. 8/7381

Wall pocket, ca. 1900. Tomah Joseph (1837–1914), Passamaquoddy (Peter Dana Point, Maine). Folded, sewn, and etched birchbark with leather thong. Width 36 cm., height 37 cm. 10/4353

Covered basket, ca. 1910. Weaver unknown, Abenaki (Odanak, Quebec). Wicker-plaited black-ash splints with curlicue (diamond) weave and applied splint flower. Length 34.5 cm., height 17 cm. 22/1345

Potato basket, 2003. Donald and Mary Sanipass, Micmac (Presque Isle, Maine). Wicker-plaited brown-ash splints with carved wooden handle. Diam. 39 cm., height 42 cm. 26/1699

Covered fancy basket, 2003. Rocky Keezer, Passamaquoddy (Perry, Maine). Wicker-plaited natural and dyed brown-ash splints and sweet grass. Diam. 25 cm., height 17 cm. 26/1696

Mount Katahdin butterfly basket, 2003. Fred Tomah, Maliseet (Houlton, Maine). Wicker- and twill-plaited natural and dyed black-ash splints with splint butterfly. Diam. 30 cm., height 20 cm. 26/1583

Ear of corn, 2003. Theresa Hoffman (b. 1958), Penobscot (Waterville, Maine). Natural and dyed wicker-plaited black-ash splints with wart-weave overlay. Diam. 10 cm., height 42 cm. 26/1694

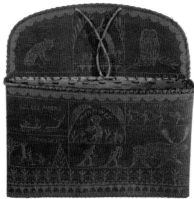

10/4353

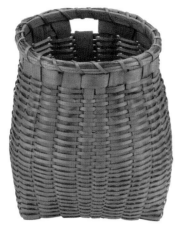

8/7381

22/1345

26/1699

26/1696

26/1583

26/1694

BASKETS FROM
NMAI'S COLLECTIONS

ABENAKI

Covered container, ca. 1900.
Weaver unknown, Abenaki (New
England/Quebec). Folded, sewn,
and etched birchbark with
sweet-grass and spruce-root
trim. Width 16 cm., height 16.5
cm. 24/4260

Covered basket, ca. 1910.
Weaver unknown, Abenaki
(Odanak, Quebec). Wicker-plait-
ed black ash splints with
curlicue (diamond) weave and
applied splint flower. Length
34.5 cm., height 17 cm.
22/1345

Fancy dish with handles,
1910. Weaver unknown, St.
Francis Abenaki (Odanak,
Quebec). Checker- and wicker-
plaited black ash splints with
lace-weave and silk-ribbon trim,
braided sweet-grass handles,
and velveteen lining. Width 36
cm., height 17 cm. 11/6999

ACHOMAWI (PIT RIVER)

Closed burden basket, ca.
1890. Weaver unknown,
Achomawi (northern California).
Four-strand full-twist overlay-
twined hazel shoots with
conifer root, bear grass, and
redbud. Diam. 53.3 cm., height
48.5 cm. 25/1344

Storage container, ca. 1910.
Weaver unknown, Achomawi
(northern California). Four-
strand full-twist overlay-twined
conifer root, with white bear
grass and split redbud shoots.
Diam. 48 cm., height 35 cm.
23/2762

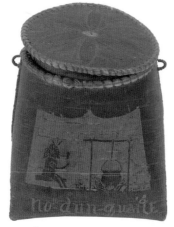

24/4260

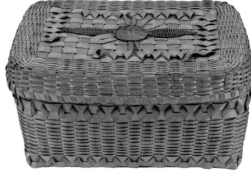

22/1345

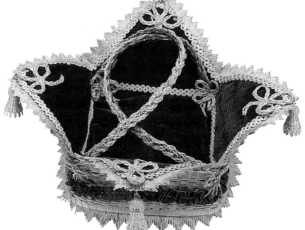

11/6999

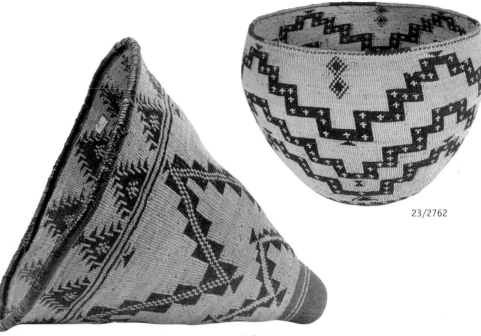

23/2762

25/1344

AKIMEL O'ODHAM

Tray, ca. 1890. Weaver unknown, Akimel O'odham (Arizona). Bundle-coiled split cattail with willow and martynia stitches. Diam. 58 cm., height 21 cm. 23/1824

Made-for-sale bowl, ca. 1900. Weaver unknown, Akimel O'odham (southern Arizona). Bundle-coiled split cattail with willow and martynia stitches and whip-stitch rim. Diam. 14.5 cm., height 8.3 cm. 20/8364

Bowl, ca. 1920. Weaver unknown, Akimel O'odham (southern Arizona). Bundle-coiled cattail with cottonwood and martynia stitches. Diam. 12.3 cm. height 12.5 cm. 10/8171

Basket, ca. 1920. Weaver unknown, Akimel O'odham (southern Arizona). Bundle-coiled willow with stitching in natural and dyed willow and martynia stitches. Width 11.5 cm., height 30 cm. 12/324

ALEUT

Covered trinket basket, ca. 1880. Weaver unknown, Aleut (Aleutian Islands, Alaska). Plain closed-twined weave with parallel warp of wild rye grass, false embroidered with silk floss. Diam. 18 cm., height 19 cm. 9/7038

Carrying basket, ca. 1910. Weaver unknown, Aleut (Aleutian Islands, Alaska). Plain open-twined weave with crossed warps of wild rye grass, false embroidered with wool yarns, with braided rim. Diam. 37 cm., height 24.5 cm. 15/6363

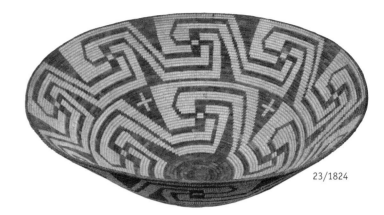

23/1824

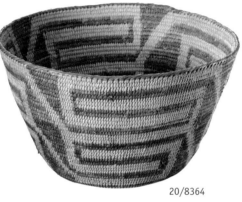

20/8364

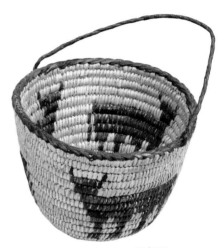

10/8171

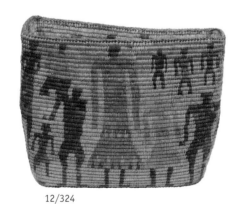

12/324

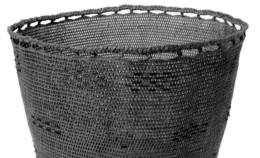

15/6363

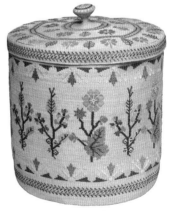

9/7038

ALEUT

Carrying basket, ca. 1920. Weaver unknown, Aleut (Aleutian Islands, Alaska). Plain open-twined weave with parallel warps of wild rye grass, false embroidered with wool yarn and feathers. Diam. 29.5 cm., height 21.8 cm. 20/8386

Work basket, ca. 1940. Weaver unknown, Aleut (Aleutian Islands, Alaska). Plain open-twined weave with parallel warps of wild rye grass, false embroidered with wool yarn; braided rim. Diam. 25 cm., height 16.4 cm. 19/4532

ALUTIIQ (KONIAG)

Bowl, ca. 1890. Weaver unknown, Alutiiq (Alaska). Closed-twined natural spruce root, false embroidered with natural and dyed bear grass; rim finish of lattice-twined rows. Diam. 24 cm., height 25.5 cm. 18/6475

Basket, ca. 1900. Weaver unknown, Alutiiq (southeastern Alaska). Closed-twined natural and dyed spruce root, false embroidered with natural and dyed canary grass. Diam. 24 cm., height 21 cm. 15/6591

Painted hat, ca. 1910. Weaver unknown, Alutiiq (Kodiak Island, Alaska). Variously twined spruce root, painted and decorated with glass beads, dentalium shells, red wool cloth, and walrus whiskers. Diam. 58 cm., height 16 cm. 6/9253

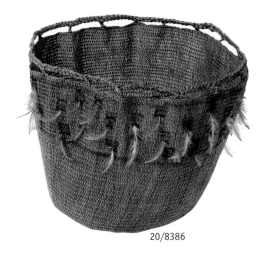

20/8386

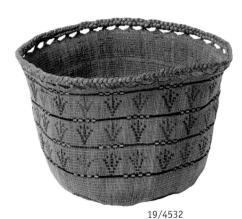

19/4532

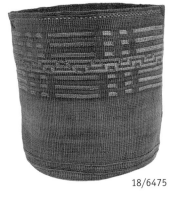

18/6475

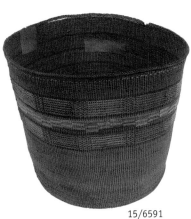

15/6591

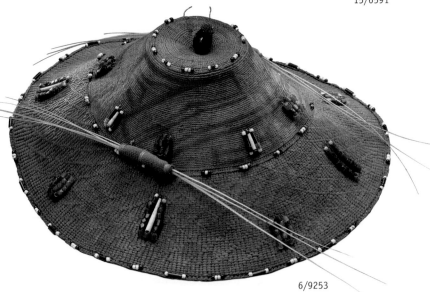

6/9253

APACHE

Closed burden basket, ca. 1890. Weaver unknown, Chiricahua Apache (New Mexico). Diagonal- and plain-twined partially peeled sumac shoots with attached tin cones. Diam. 33.5 cm., height 30.4 cm. 22/7646

Tray, ca. 1890. Weaver unknown, White Mountain Apache (Arizona). Three-rod coiled willow shoots with willow and martynia stitches. Diam. 34 cm., height 11.5 cm. 14/2162

Olla, ca. 1900. Weaver unknown, White Mountain Apache (Arizona). Three-rod coiled willow shoots with willow and martynia stitches. Length 39 cm., height 29.5 cm. 10/5419

Bowl, ca. 1900. Weaver unknown, White Mountain Apache (Arizona). Three-rod coiled willow shoots with willow and martynia stitches; plain bound rim of martynia. Diam. 33 cm., height 10.5 cm. 14/2161

Closed burden basket, ca. 1900. Weaver unknown, White Mountain Apache (Arizona). Plain- and diagonal-twined natural and dyed willow and martynia with leather straps and fringes. Diam. 39.8 cm., height 34 cm. 20/8225

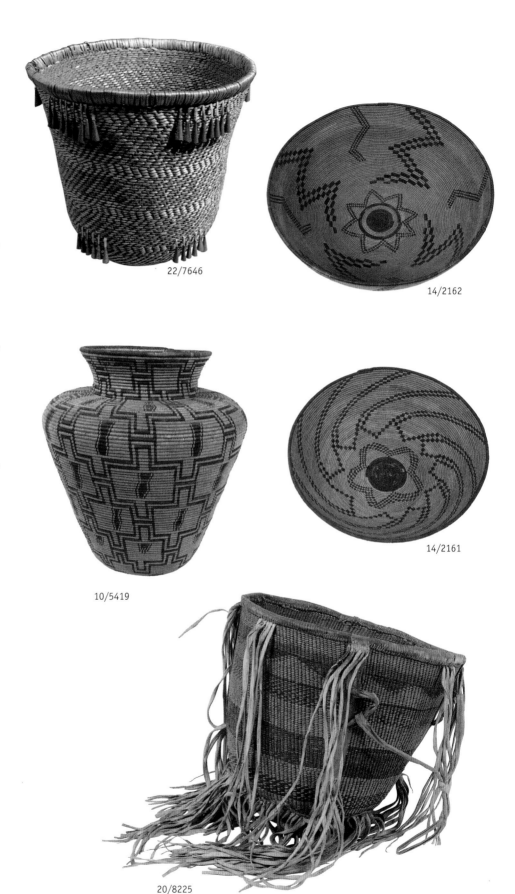

22/7646

14/2162

10/5419

14/2161

20/8225

ARIKARA

Closed burden basket, ca. 1900. Mrs. Snow, Arikara (Fort Berthold Reservation, North Dakota). Two-over-two twill-plaited willow and box-elder splints over willow-rod framework. Diam. 52 cm., height 44 cm. 1/3805

CAHUILLA

Bowl, ca. 1890. Weaver unknown, Serrano Cahuilla (southern California). Bundle-coiled deer-grass stems with natural juncus stitches. Diam. 37 cm., height 17.8 cm. 24/7735

Hat, ca. 1900. Weaver unknown, Cahuilla (Santa Rosa Reservation, California). Bundle-coiled deer-grass stems with sumac and natural and dyed juncus stitches. Diam. 21.7 cm., height 11.9 cm. 8/3933

CHEROKEE

Pocketbook, ca. 1900. Weaver unknown, Cherokee (North Carolina). Wicker-plaited natural and dyed white-oak splints with wooden frame and handle. Length 21.5 cm., height 21.5 cm. 1/9163

Shopper, ca. 1965. Weaver unknown, Cherokee (North Carolina). Wicker-plaited natural and dyed white-oak splints. Diam. 22.5cm., height 18.5cm. 26/169

CHILCOTIN

Closed burden basket, ca. 1920. Weaver unknown, Chilcotin (interior British Columbia). Bundle-coiled cedar root with imbricated design of bear grass and cherry bark, with rim wrapping of split bird-quills and strap of twined cotton string and wool yarn. Width 38.5 cm., height 28.2 cm. 23/2761

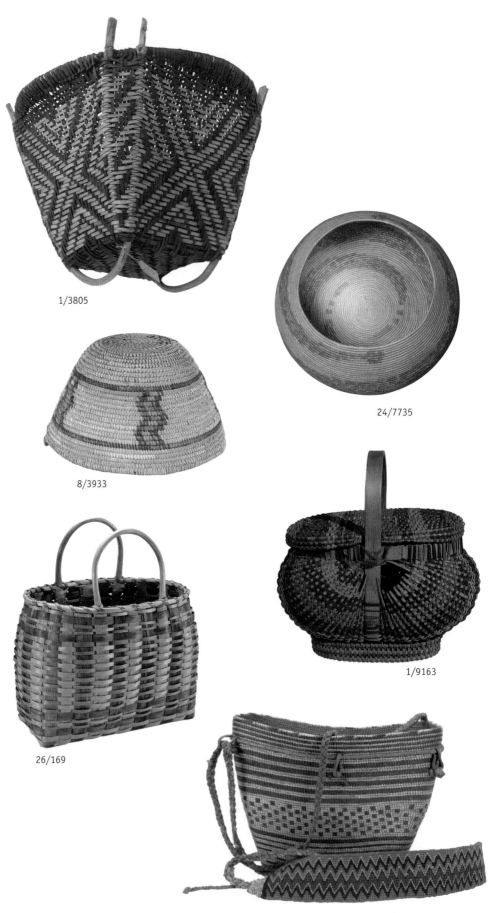

1/3805

8/3933

24/7735

26/169

1/9163

23/2761

CHINOOK

Basket, ca. 1820. Weaver unknown, Chinook, Clatsop, or Wasco (Washington). Wrap-twined bear grass and cherry bark over cedar-bark warps. Diam. 9 cm., height 14 cm. 7/8125

Covered basket, 2003. Francis "Millie" Lagergren, Chinook (Grand Ronde, Oregon). Bundle-coiled grass with natural and dyed raffia stitches. Diam. 20 cm., height 18 cm. 26/2612

CHITIMACHA

Small trunk and cover, ca. 1920. Weaver unknown, Chitimacha (Louisiana). Double-woven, complex twill-plaited natural and dyed river cane. Length 20 cm., height 15.5 cm. 11/8264

Nesting baskets, ca. 1965. Weaver unknown, Chitimacha (Louisiana). Complex twill-plaited natural and dyed river cane. Largest: diam. 23 cm. 26/173

7/8125

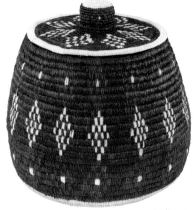

26/2612

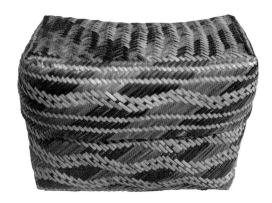

11/8264

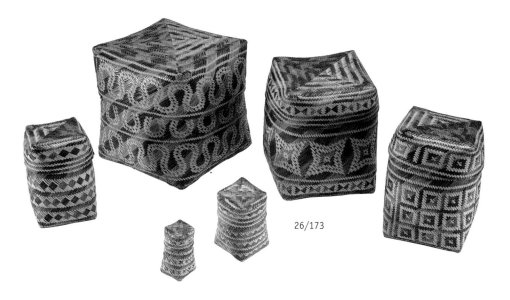

26/173

CHOCTAW

Closed burden basket, ca. 1890. Weaver unknown, Choctaw (Mississippi). Checker- and twill-plaited natural and dyed river cane with leather carrying strap. Diam. 57 cm., height 61.5 cm. 23/1156

Winnowing basket, ca. 1900. Weaver unknown, Choctaw (St. Tammany Parish, Louisiana). Complex twill-plaited river cane. Length 38 cm., width 31.5 cm. 1/8453

Medicine basket, ca 1940. Weaver unknown, Choctaw (Mississippi). Complex twill-plaited natural and dyed river cane with double rim and handle. Width 26 cm., height 18.5 cm. 22/5213

Mat, 1964. Sweenie Mills, Choctaw (Pearl River, Mississippi). Complex twill-plaited natural and dyed river cane. Length 116 cm., width 50 cm. 23/8249

Bowl, 1965. Beauty Denson, Choctaw (Standing Pine, Mississippi). Double-woven, three-over-three twill-plaited natural and dyed river cane. Diam. 25.6 cm., height 16.2 cm. 26/1913

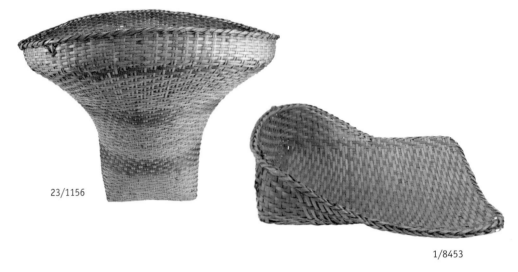

23/1156

1/8453

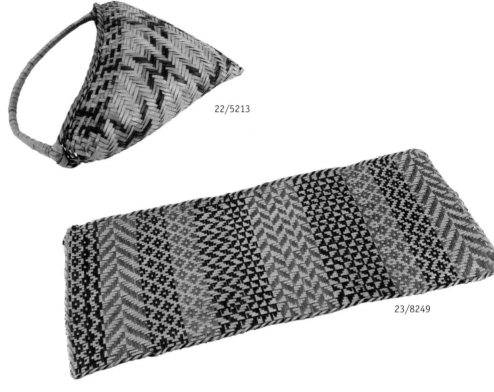

22/5213

23/8249

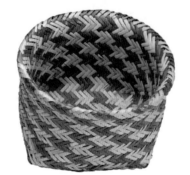

26/1913

CHUMASH

Tray, ca. 1780. Weaver unknown, Chumash (Santa Barbara, California). Three-rod coiled juncus rushes with natural and dyed juncus stitches. Diam. 41.5 cm., height 10.5 cm. 23/7050

Presentation tray, ca. 1825. Juana Basilia Sitmelelene (1780–1838), Chumash (Santa Barbara, California). Bundle-coiled juncus stems with natural and dyed juncus stitches. Diam. 48 cm., height 8.5 cm. 23/132

Lidded jar, ca. 1850. Weaver unknown, Chumash (Santa Ynez, California). Three-rod coiled grass with natural and dyed juncus and sumac stitches. Diam. 31 cm., height 22 cm. 21/4783

Serving tray, ca. 1880. Weaver unknown, possibly Chumash (Santa Barbara County, California). Bundle-coiled juncus stems with natural and dyed juncus stitches. Diam. 33 cm., height 9 cm. 9/7331

Serving or cooking bowl, ca. 1890. Attributed to Petra Pico (1834–1902), Chumash (Santa Inez, California). Bundle-coiled juncus stems with natural and dyed juncus stitches. Diam. 48 cm., Height 24.2 cm. 15/9013

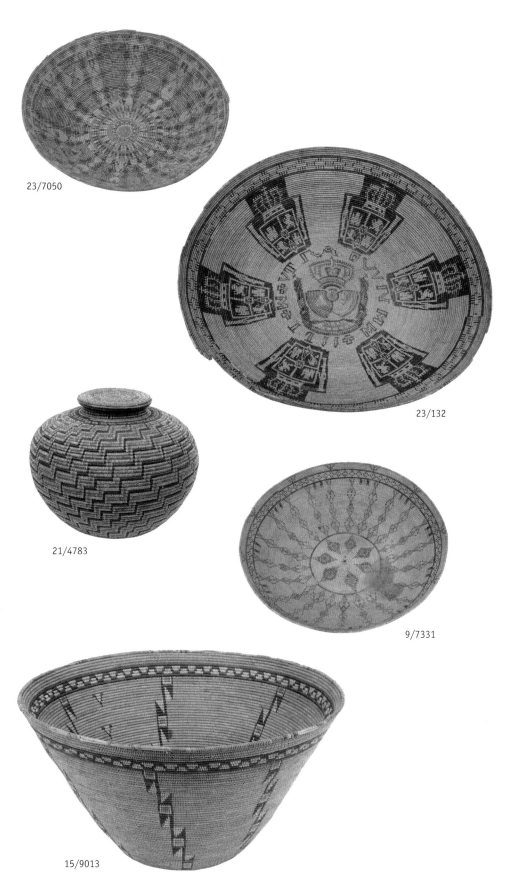

23/7050

23/132

21/4783

9/7331

15/9013

CLATSOP

Pouch, ca. 1930. Weaver unknown, Clatsop (Oregon). Closed-twined hemp, false embroidered with bear grass and cherry bark. Length 15.5 cm., width 10.5 cm. 22/4544

COUSHATTA

Cornmeal-sifting tray, ca. 1910. Weaver unknown, Coushatta (near Elton, Louisiana). Complex twill-plaited river cane. Length 15 cm., height 10.8 cm. 1/8487

COWLITZ

Carrying basket, ca. 1930. Weaver unknown, Cowlitz (Washington). Bundle-coiled cedar root with cedar-root stitches and imbricated design of equisetum and phragmites. Length 36 cm., height 24 cm. 20/8230

Closed burden basket, ca. 1900. Weaver unknown, Cowlitz (Washington). Bundle-coiled conifer root with conifer-root stitches and imbricated design of cherry bark and bear grass. Length 35 cm., height 28.5 cm. 22/5104

22/4544

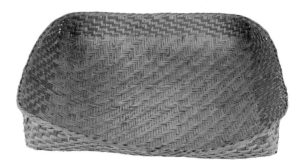

1/8487

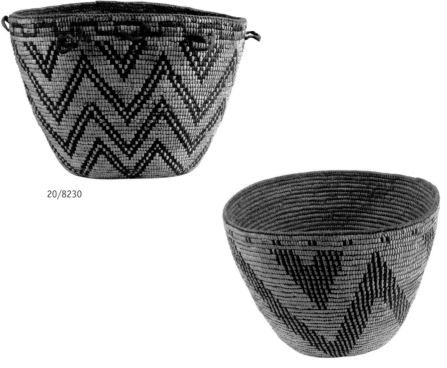

20/8230

22/5104

HAIDA

Hat, ca. 1820. Weaver unknown, Haida (Queen Charlotte Islands, British Columbia). Plain-, diagonal-, and three-strand-twined spruce root with painted decoration. Width 33.7 cm., height 28.6 cm. 1824

Hat, ca. 1880. Weaver unknown, Haida (Queen Charlotte Islands, British Columbia). Plain- and diagonal-twined natural and dyed spruce root. Diam. 32 cm., height 13.5 cm. 6542

Hat, ca. 1880. Weaver unknown, Haida (Queen Charlotte Islands, British Columbia). Plain-, diagonal-, and three-strand-twined spruce root with lattice-twined rim and braided edge. Diam. 37 cm., height 17 cm. 15/6746

Small burden basket, ca. 1890. Weaver unknown, Haida (Queen Charlotte Islands, British Columbia). Plain closed-twined spruce root. Diam. 11 cm., height 11.3 cm. 8640

Hat, ca. 1900. Weaver unknown, Haida (Queen Charlotte Islands, British Columbia). Plain-, diagonal-, and three-strand-twined spruce root with painted decoration. Diam. 42 cm., height 17.5 cm. 9/8015

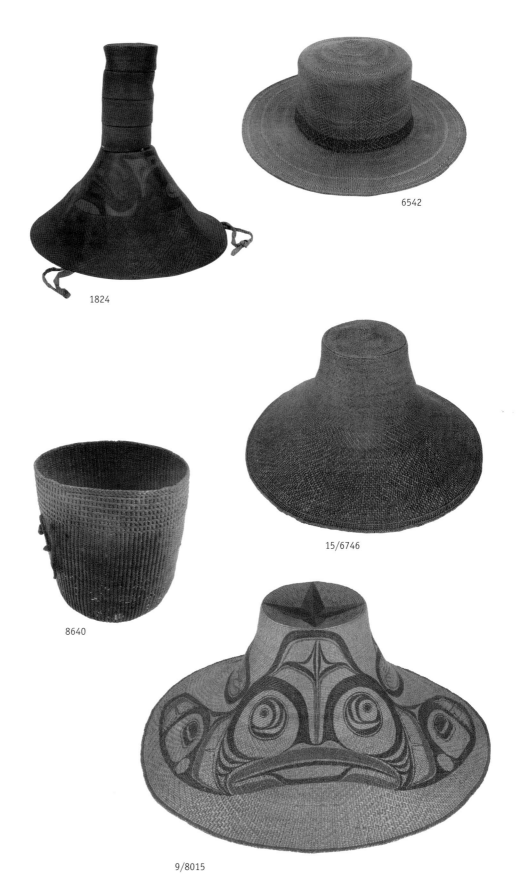

6542

1824

15/6746

8640

9/8015

HAIDA

Basket, ca. 1900. Weaver unknown, Haida (Queen Charlotte Island, British Columbia). Plain closed- and diagonal-twined natural and dyed spruce root. Diam. 24.5 cm., height 27.2 cm. 10/998

Berry-picking basket, ca. 1900. Weaver unknown, Haida (Vancouver Island, British Columbia). Plain and diagonal closed-twined spruce root. Diam. 12 cm., height 13.5 cm. 21/1696

Covered bowl, ca. 1900. Weaver unknown, Haida (Queen Charlotte Islands, British Columbia). Closed-twined spruce root with painted decoration. Diam. 8.5 cm., height 5 cm. 21/1697

Bowl, ca. 1912. Weaver unknown, Haida (Queen Charlotte Islands, British Columbia). Plain- and lattice-twined natural and dyed spruce root. Diam. 22.5 cm., height 21.5 cm. 5/4252

Miniature basket, 2003. Isabel Rorick, Haida (Hornby Island, British Columbia). Plain and diagonal closed-twined natural and dyed spruce root. Diam. 9. cm., height 8 cm. 26/1697

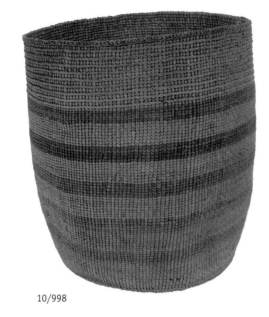

10/998

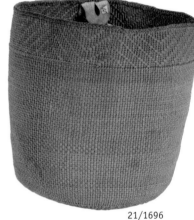

21/1696

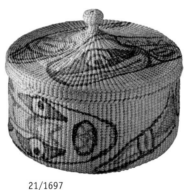
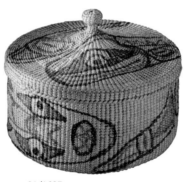

21/1697

5/4252

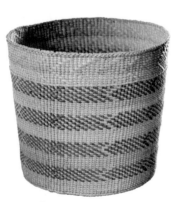

26/1697

HO-CHUNK (WINNEBAGO)

Bag, ca. 1880. Weaver unknown, Ho-chunk (central Wisconsin). Plain open-twined weave with crossed warps of cotton string, wefts of woolen yarn. Width 48 cm., height 37 cm. 10/3096

Bag, ca. 1920. Weaver unknown, Ho-chunk (Tomah, Wisconsin). Plain open-twined weave with parallel warps of natural and dyed basswood bark; cotton string weft. Width 46 cm., height 39 cm. 12/3054

HUPA

Closed burden basket, ca. 1900. Weaver unknown, Hupa (northwestern California). Plain- and diagonal-twined conifer root with half-twist overlay of bear grass. Diam. 57 cm., height 51.3 cm. 8/2943

Tray, ca. 1900. Weaver unknown, Hupa (northwestern California). Open-twined hazel shoots with rim finish of wicker-plaited bundles of shoots. Diam. 45 cm., height 9.5 cm. 15/6876

Woman's hat, ca. 1925. Weaver unknown, Hupa (northern California). Four-strand half-twist overlay-twined hazel shoots with bear grass and maidenhair-fern stems. Diam. 17.6 cm., height 8.8 cm. 22/5157

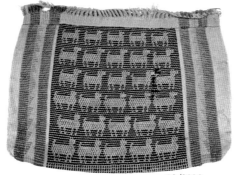

10/3096

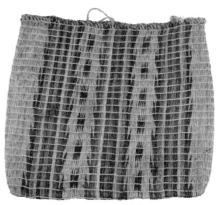

12/3054

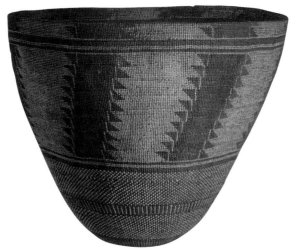

8/2943

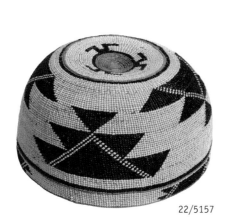

22/5157

15/6876

HURON

Birchbark tray, ca. 1840. Weaver unknown, Huron (Ontario, Canada). Shaped and sewn birchbark embroidered with natural and dyed moose hair, rim trimmed with moose hair and cotton thread. Length 23.5 cm., width 20 cm. 23/2167

23/2167

INUPIAQ ESKIMO

Trinket basket, ca. 1935. Abe P. Simmons (1893–1969), Inupiaq Eskimo (Point Barrow, Alaska). One-rod coiled light-colored baleen with black baleen stitches; carved ivory basal disk and finial. Diam. 14 cm., height 13 cm. 23/7040

Trinket basket, 1986. Elijah Attungana (b. 1933), Inupiaq Eskimo (Point Hope, Alaska). Coiled baleen stitches over single-rod baleen rods; carved ivory basal disk and finial. Diam. 8.1 cm., height 9.9 cm. 26/188

26/188

23/7040

KAROK

Basket and cover, ca. 1910. Elizabeth Hickox (1875–1947), Karok (Humboldt County, California). Plain closed-twined willow shoots with half-twist overlay of bear grass and maidenhair-fern stems. Diam. 29 cm., height 22 cm. 16/3589

Basket and cover, ca. 1920. Elizabeth Hickox (1875–1947), Karok (Humboldt County, California). Plain closed-twined willow shoots with half-twist overlay of bear grass and maidenhair-fern stems. Diam. 6 cm., height 7 cm. 24/6944

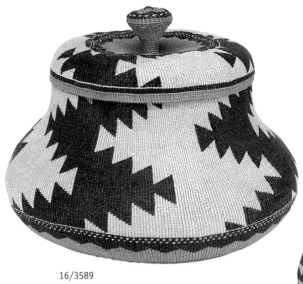

16/3589

24/6944

KAWAIISU

Shouldered storage jar, ca. 1890. Weaver unknown, Kawaiisu (Kern County, California). Bundle-coiled deer grass with sumac and yucca-root stitches. Diam. 21.5 cm., height 16.5 cm. 19/8189

KICKAPOO

Work basket, ca. 1910. Weaver unknown, Kickapoo (Oklahoma). Checker-plaited and twined natural and dyed cattail and rushes. Length 45 cm., height 12 cm. 2/4880

KLIKITAT

Small berrying basket, ca. 1915. Weaver unknown, Klikitat (Washington). Bundle-coiled cedar root with cedar-root stitches and imbricated design of equisetum; rim of coiled loops with braided edge. Diam. 16 cm., height 16.8 cm. 15/6422

Closed burden basket, ca. 1915. Weaver unknown, Klikitat (Washington). Bundle-coiled conifer root with design in white bear grass, cherry bark, and black-dyed equisetum root. Diam. 34 cm., height 41.5 cm. 15/6438

Small berrying basket, ca. 1920. Weaver unknown, Klikitat (Washington). Bundle-coiled cedar root with imbricated design of dyed and natural bear grass. Diam. 14.2 cm., height 14.3 cm. 15/6425

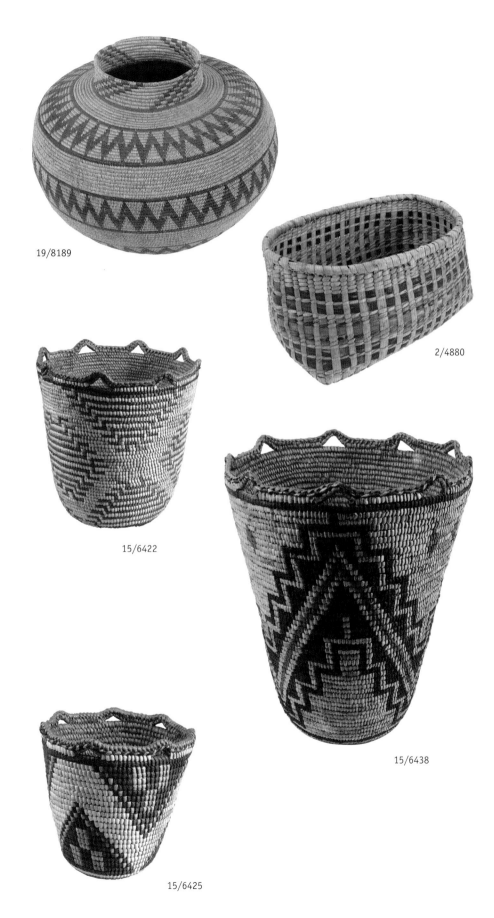

19/8189

2/4880

15/6422

15/6438

15/6425

KLIKITAT

Berrying basket, 2003. Nettie Jackson, Klikitat (Washington). Bundle-coiled conifer root with conifer-root stitches and imbricated design of bear grass and cherry bark. Diam. 20.5 cm., height 26 cm. 26/2611

KOYUKON

Tray, ca. 1965. Weaver unknown, possibly Koyukon (Alaska). One-rod coiled willow shoots with noninterlocking stitches of dyed and natural conifer root. Diam. 42 cm., height 2.5 cm. 26/1413

KUMEYAAY

Made-for-sale tray, ca. 1900. Weaver unknown, Kumeyaay (southern California). Bundle-coiled deer grass with natural and dyed juncus stitches. Diam. 12 cm., height 38.6 cm. 24/3083

Closed burden basket, ca. 1920. Weaver unknown, Kumeyaay (southern California). Bundle-coiled deer-grass stems with sumac and dyed juncus stitches. Diam. 53 cm., height 24.5 cm. 12/3353

KWAKWAKA'WAKW (KWAKIUTL)

Storage basket, ca. 1900. Weaver unknown, Kwakwaka'wakw (Nemquic Village, coastal British Columbia). Checker-plaited cedar bark with open-spaced intervals and crossed warps. Width 37.5 cm., height 23 cm. 1/3288

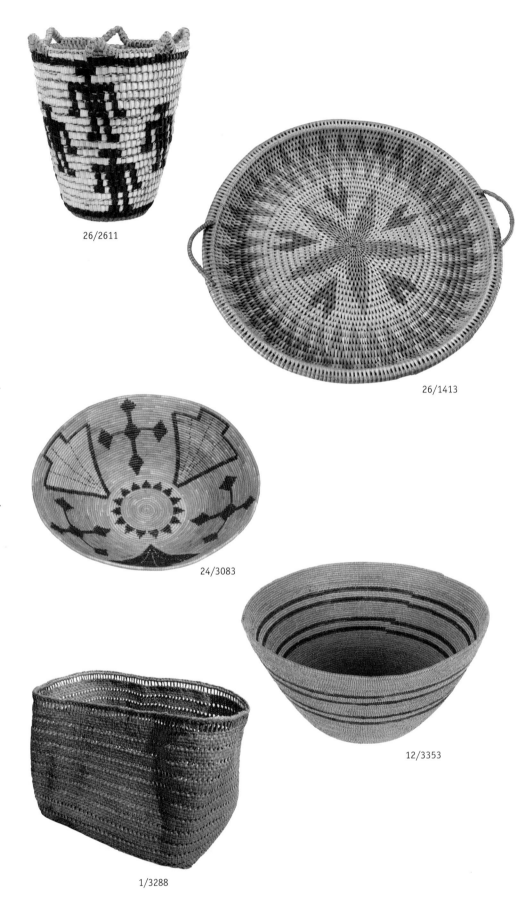

26/2611

26/1413

24/3083

12/3353

1/3288

MAHICAN

Fruit basket, ca. 1840. Weaver unknown, Stockbridge Mahican (western Massachusetts). Checker- and wicker-plaited black ash splints with swabbed and stamped decoration. Diam. 35.5 cm., height 15.5 cm. 19/8287

MAIDU

Gift basket, ca. 1880. Weaver unknown, Konkow Maidu (central California). Three-rod coiled willow shoots with split maple shoots and fall redbud stitches. Length 29 cm., width 22 cm. 24/2842

Closed burden basket, ca. 1890. Weaver unknown, Mountain Maidu (northeastern California). Plain-twined willow and pine root with full-twist overlay of peeled and unpeeled redbud. Diam. 38 cm., height 36.3 cm. 9539

Cooking or serving bowl, ca. 1920. Weaver unknown, Nisenan Maidu (northern California). Three-rod coiled with willow rods and fall and spring redbud stitches. Diam. 53 cm., height 34.5 cm. 21/5377

19/8287

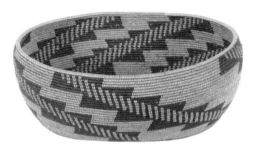

24/2842

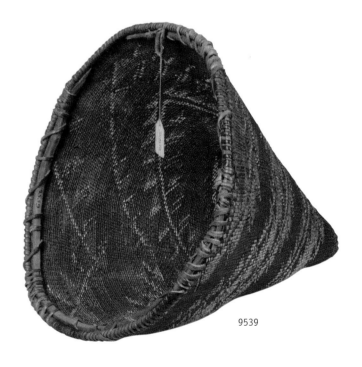

9539

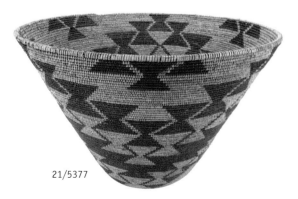

21/5377

MAKAH

Lidded bowl, ca. 1900. Weaver unknown, Makah (Neah Bay, Washington). Wrap-twined natural and dyed bear grass on cedar-bark warps, with plaited cedar-bark start. Diam. 8.2 cm., height 4.5 cm. 5/3627

Lidded jar, ca. 1900. Weaver unknown, Makah (Neah Bay, Washington). Wrap-twined natural and dyed bear grass on cedar-bark warps, with plaited cedar-bark start. Diam. 10 cm., height 10 cm. 5/9915

Storage basket, ca. 1900. Weaver unknown, Makah (Neah Bay, Washington). Two-over-two twill-plaited spruce and cedar-root splints with vine-wrapped rim. Width 58 cm., height 47.5 cm. 5/9945

Lidded treasure bowl, ca. 1900. Weaver unknown, Makah (Neah Bay, Washington). Closed wrap-twined natural and dyed bear grass on checker-plaited cedar-bark foundation. Diam. 9 cm., height 4.5 cm. 15/6679

Novelty bowl and cover, ca. 1910. Weaver unknown, Makah (Neah Bay, Washington). Wrap-twined natural and dyed bear grass on cedar-bark warps, with plaited cedar-bark start. Width 12.7 cm., height 7.8 cm. 5/9910

Made-for-sale novelty, ca. 1930. Weaver unknown, Makah (Neah Bay, Washington). Deer antlers covered with wrap-twined basketry of natural and dyed bear grass on cedar bark foundation. Length 41 cm., width 34 cm., height 21 cm. 24/4475

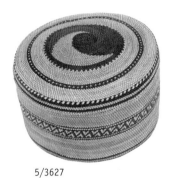

5/3627

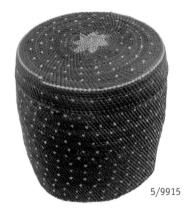

5/9915

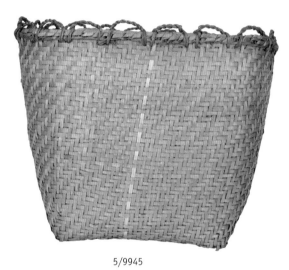

5/9945

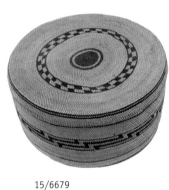

15/6679

24/4475

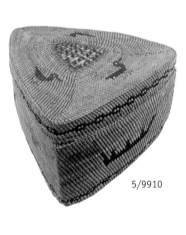

5/9910

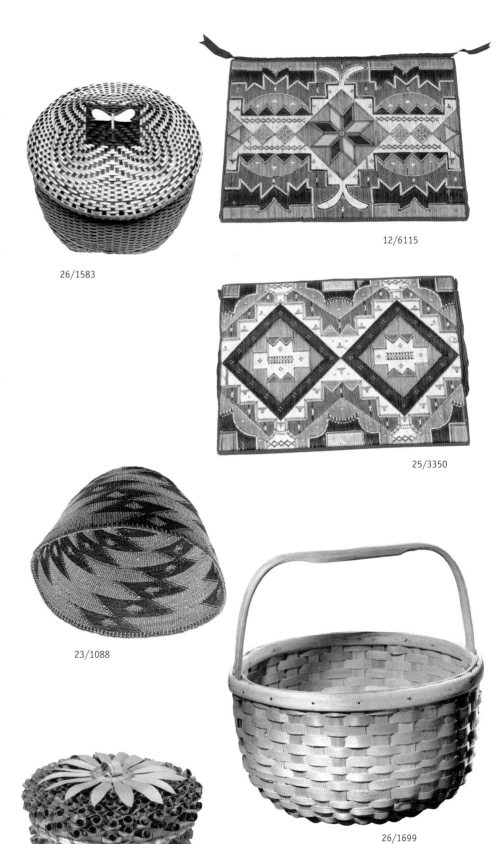

MALISEET

Mount Katahdin butterfly basket, 2003. Fred Tomah, Maliseet (Houlton, Maine). Wicker- and twill-plaited natural and dyed black ash splints with splint butterfly. Diam. 30 cm., height 20 cm. 26/1583

MICMAC

Birchbark portfolio, ca. 1920 . Weaver unknown, Micmac (Nova Scotia). Birchbark embroidered with dyed and natural porcupine quills and backed with fabric. Length 35.5 cm., width 26 cm. 12/6115

Portfolio, ca. 1920. Weaver unknown, Micmac (Nova Scotia). Birchbark embroidered with dyed and natural porcupine quills and backed with fabric. Length 36 cm., width 26 cm. 25/3350

Potato basket, 2003. Donald and Mary Sanipass, Micmac (Presque Isle, Maine). Wicker-plaited brown ash splints with carved wooden handle. Diam. 39 cm., height 42 cm. 26/1699

MODOC

Hat, ca. 1900. Weaver unknown, Modoc (northeastern California). Closed-twined dyed and natural cattail over three-ply twined cotton string start. Diam. 18.7 cm., height 11.1 cm. 23/1088

MOHAWK

Strawberry basket, 1969. Eva Point, Mohawk (Canada). Wicker-plaited natural and dyed black ash splints with wart-weave overlay, applied splint leaves, and sweet-grass rim. Diam. 14.8 cm., height 10.3 cm. 26/1941

26/1583

12/6115

25/3350

23/1088

26/1699

26/1941

MONO

Serving or cooking bowl, ca. 1900. Weaver unknown, Western Mono (central California). Bundle-coiled deer-grass stems with sedge, bracken-fern, and bird-quill stitches. Diam. 46.6 cm., height 25.5 cm. 4/8789

Shouldered treasure jar, ca. 1910. Weaver unknown, Western Mono (central California). Bundle-coiled deer-grass stems with sedge and bracken-fern stitches. Diam. 25 cm., height 14.5 cm. 16/5503

Shouldered jar, ca. 1910. Weaver unknown, Western Mono (central California). Bundle-coiled deer-grass stems with sedge and bracken-fern-root stitches. Diam. 25 cm., height 8.5 cm. 20/8343

Cooking basket, ca. 1952. Annie Wentz, Western Mono (Northfork, California). Bundle-coiled deer grass with bracken-fern and sedge-root stitches. Diam. 51.3cm., height 28.5cm. 26/1932

NAVAJO

Bowl, ca. 1910. Weaver unknown, Navajo (Arizona). Three-rod coiled sumac shoots with natural and dyed sumac stitches; braided rim finish. Diam. 35.5 cm., height 8.5 cm. 11/5490

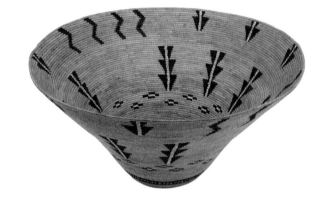

4/8789

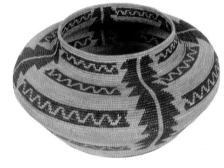

16/5503

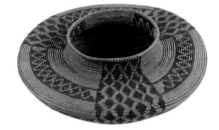

20/8343

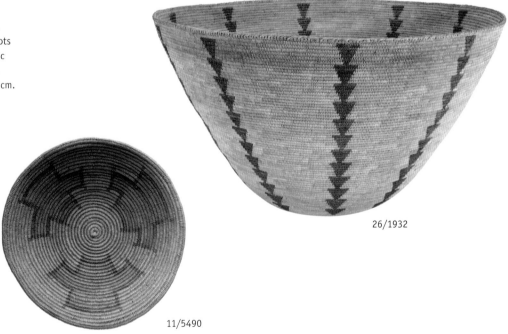

26/1932

11/5490

NEZ PERCE

Bag, ca. 1890. Weaver unknown, Nez Perce (Idaho). Closed-twined cornhusk and hemp weft over hemp foundation, false embroidered with wool yarn and cornhusk. Length 59 cm., width 48 cm. 23/1138

Woman's hat, ca. 1910. Weaver unknown, Nez Perce (Idaho). Wrap-twined natural and dyed cornhusk over hemp foundation. Diam. 19 cm., height 18.5 cm. 22/9589

Hat, 2003. Jenny Williams, Nez Perce (Pendleton, Oregon). Closed wrap-twined cornhusk and wool yarn over hemp-cordage foundation, with cotton cloth lining and leather rim. Diam. 17.5cm., height 17cm. 26/2639

NUU-CHAH-NULTH (NOOTKA)

Whaler's hat, ca. 1800. Weaver unknown, Nuu-chah-nulth (Vancouver Island, British Columbia). Closed wrap-twined bear grass and equisetum over cedar-bark foundation. Diam. 24 cm., height 23.5 cm. 16/4130

Fish basket, ca. 1880. Weaver unknown, Nuu-chah-nulth (Vancouver Island, British Columbia). Open lattice-twined conifer root. Width 33.8 cm., height 30.8 cm. 5/6766

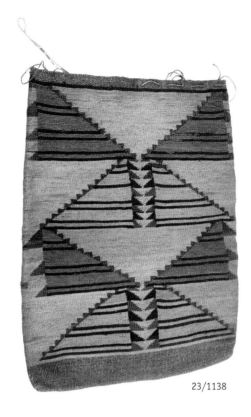

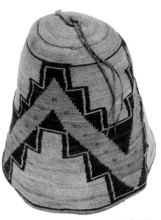

22/9589

23/1138

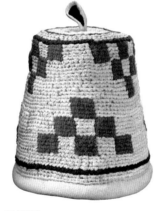

26/2639

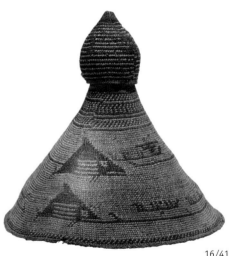

16/4130

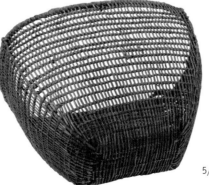

5/6766

NUU-CHAH-NULTH (NOOTKA)

Made-for-sale trinket basket and cover, ca. 1900. Weaver unknown, Nuu-chah-nulth (Vancouver Island, British Columbia). Alternating rows of wrap-twined and checker-plaited natural and dyed bear grass on cedar-bark warps. Length 28.5 cm., width 14.5 cm., height 15 cm. 25/1256

Work basket, ca. 1910. Weaver unknown, Nuu-chah-nulth (Vancouver Island, British Columbia). Bias-plaited natural and dyed cedar bark with twisted cedar bark rim strap. Width 40 cm., height 36 cm. 15/6696

OHLONE

Winnowing tray, ca. 1780. Weaver unknown, Ohlone (Monterey County, California). Diagonal-twined sedge and equisetum root. Length 43.5 cm., width 26 cm., height 12 cm. 5/786

ONEIDA

Covered storage basket, ca. 1840. Weaver unknown, Oneida (central New York). Checker- and wicker-plaited black ash splints with potato-stamped and painted decoration. Length 56 cm., height 29.5 cm. 24/2830

OSAGE

Bag, ca. 1900. Weaver unknown, Osage (Oklahoma). Weft-face twined woolen yarn over cotton-string warp. Width 42 cm., height 34.5 cm. 2/860

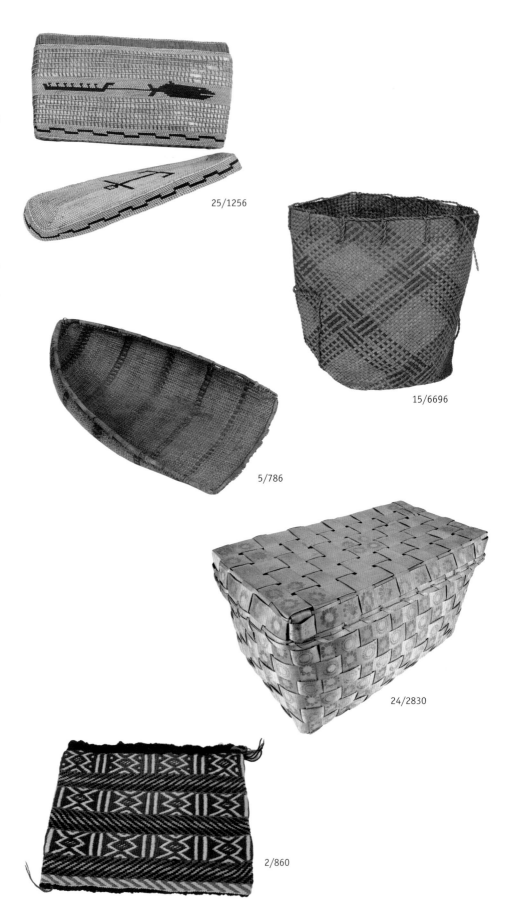

25/1256

15/6696

5/786

24/2830

2/860

PAIUTE

Water bottle, ca. 1880. Weaver unknown, Paiute (Nevada). Diagonal-twined split peeled willow shoots with raised bands of three-strand twining. Diam. 26 cm., height 39 cm. 15/7080

Winnowing basket, ca. 1890. Weaver unknown, Paiute (Owens Valley, California). Diagonal-twined peeled split and whole willow shoots. Length 39 cm., width 36.5 cm., height 15.5 cm. 21/5411

Piñon-cone-carrying basket, ca. 1880. Weaver unknown, Kaibab Paiute (Kaibab Reservation, Arizona). Open-twined whole and split willow shoots. Diam. 71 cm., height 72 cm. 10/3272

Shouldered storage jar, ca. 1930. Weaver unknown, Moapa Paiute (Nevada). Three-rod coiled willow shoots with martynia and juncus stitches. Diam. 27 cm., height 19.5 cm. 16/4012

Winnowing tray, ca. 1900. Weaver unknown, Mono Lake Paiute (eastern California). Open-twined willow shoots with willow and bracken fern. Length 53 cm., width 46 cm. 20/9590

Hat, ca. 1900. Weaver unknown, possibly Owens Valley Paiute (eastern California). Diagonal-twined, partially peeled willow shoots with three-strand-twined start and painted decoration. Diam. 21.8 cm., height 15.8 cm. 12/2396

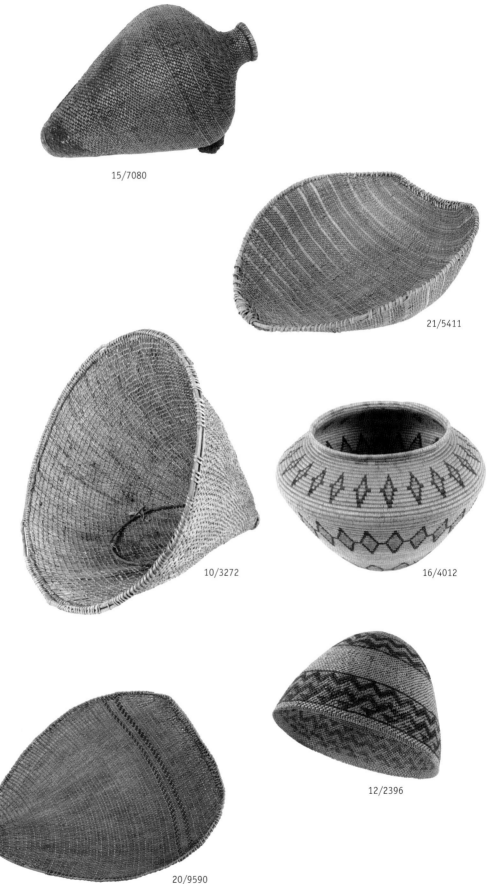

15/7080

21/5411

10/3272

16/4012

12/2396

20/9590

PAIUTE

Model fish trap, ca. 1990. Weaver unknown, Walker River Paiute (Walker River Reservation, Nevada). Plain-twined split willow shoots. Diam. 56 cm., length 25.5 cm. 13/3789

Work tray, 2003. Lucy Parker (b. 1953), Yosemite Paiute–Coast Miwok–Mono Lake Paiute–Kashaya Pomo (Lee Vining, California). Open plain-twined unpeeled willow. Diam. 62 cm., height 12 cm. 26/2687

PANAMINT SHOSHONE

Gift basket, ca. 1880. Weaver unknown, Panamint Shoshone (Inyo County, California). Two-stick and bundle-coiled willow with split willow and sumac, yucca-root, and martynia stitches. Diam. 14.5 cm., height 10 cm. 22/1928

Bowl, ca. 1910. Weaver unknown, Panamint Shoshone (Inyo County, California). Three-rod coiled willow with willow, martynia, dyed and undyed bulrush, and bird-quill stitches. Diam. 19.5 cm., height 18 cm. 10/1792

Shouldered storage jar, ca. 1910. Weaver unknown, Panamint Shoshone (southeastern California). Three-rod coiled grass stems with sumac, bulrush root, and split bird-quills. Diam. 22 cm., height 12.5 cm. 20/3584

Shouldered storage jar, ca. 1925. Weaver unknown, Panamint Shoshone (southeastern California). Three-rod coiled willow with willow, martynia, and bulrush-root stitches. Length 25 cm., height 12.5 cm. 16/3992

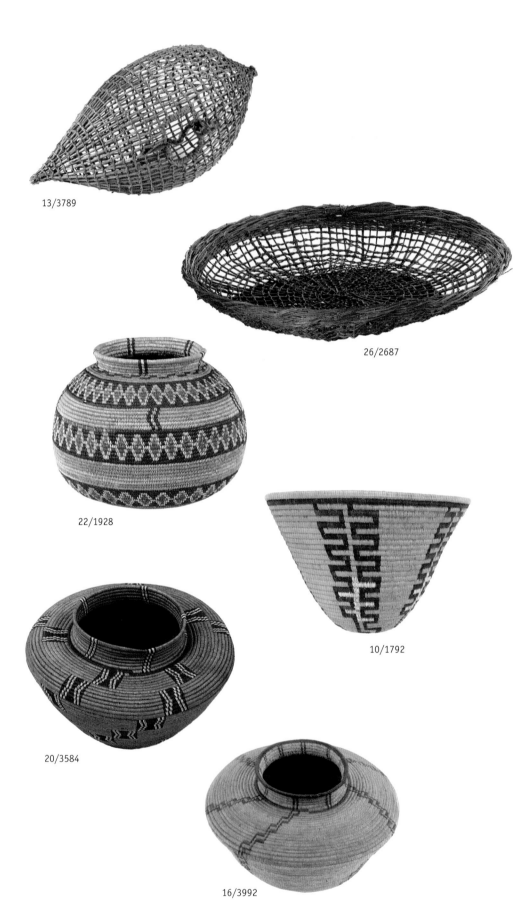

13/3789

26/2687

22/1928

10/1792

20/3584

16/3992

PASSAMAQUODDY

Storage basket and cover, ca. 1870. Weaver unknown, possibly Passamaquoddy (eastern Maine). Wicker-plaited dyed and natural black ash splints. Diam. 37 cm., height 37 cm. 20/2055

Wall pocket, ca. 1900. Tomah Joseph (1837–1914), Passamaquoddy (Peter Dana Point, Maine). Folded, sewn, and etched birchbark with leather thong. Width 36 cm., height 37 cm. 10/4353

Covered basket, 2003. Gal Fray, Passamaquoddy (Princeton, Maine). Wicker-plaited natural and dyed brown ash splints with curlicue-weave overlay and braided sweet-grass trim. Diam. 29cm., height 18cm. 26/1575

Covered basket. 2003. Jeremy Frey, Passamaquoddy (Princeton, Maine). Natural black ash splints with porcupine-weave overlay and birchbark disk sewn with porcupine quills. Diam. 27cm., height 33cm. 26/1580

Covered basket, 2003. Gal and Jeremy Frey, Passamaquoddy (Princeton, Maine). Wicker-plaited natural and dyed black ash splints with curlicue-weave overlay and braided sweet-grass trim. Diam. 8.3cm., height 7.5cm. 26/1581

Covered fancy basket, 2003. Rocky Keezer, Passamaquoddy (Perry, Maine). Wicker-plaited natural and dyed brown ash splints and sweet grass. Diam. 25cm., height 17cm. 26/1696

20/2055

10/4353

26/1575

26/1580

26/1581

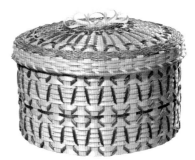

26/1696

PATWIN

Acorn-meal-sifting tray, ca. 1970. Bertha Wright Mitchell, Patwin (Colusa County, California). Three-rod coiled willow shoots with peeled spring redbud and unpeeled fall redbud stitches. Diam. 44.5 cm., height 7.5 cm. 25/4886

PAVIOTSO (NORTHERN PAIUTE)

Closed burden basket, ca. 1900. Weaver unknown, Paviotso (Pyramid Lake Reservation, Nevada). Diagonal-twined peeled and partially peeled willow shoots, with leather carrying loops. Diam. 51.2 cm., height 57.2 cm. 13/3795

Piñon-cone-carrying basket, ca. 1900. Weaver unknown, Paviotso (Pyramid Lake Reservation, Nevada). Plain open-twined whole and split willow shoots. Diam. 55 cm., height 62 cm. 13/3796

Small seed- or water-carrying basket, ca. 1920. Weaver unknown, Paviotso (Walker River Reservation, Nevada). Diagonal-twined partially peeled willow with horsehair handle. Width 13 cm., height 11 cm. 10/5314

Winnowing basket, ca. 1950. Weaver unknown, Paviotso (Klamath Lake Reservation, Oregon). Plain open-twined peeled willow shoots. Length 63.5 cm., width 53 cm. 16/5391

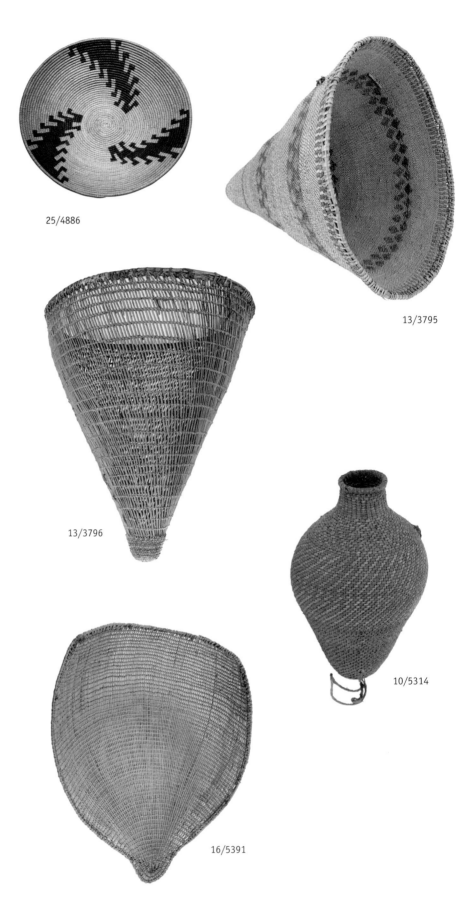

25/4886

13/3795

13/3796

10/5314

16/5391

PENOBSCOT

Work basket, 1873. Weaver unknown, Penobscot (Maine). Checker- and wicker-plaited black ash splints. Length 29.5 cm., height 12 cm. 22/5862

Covered storage basket, ca. 1880. Weaver unknown, Penobscot (central Maine). Plain- and wicker-plaited natural, swabbed, and dyed black ash splints. Diam. 29.5 cm., height 21 cm. 9/1520

Miniature pack basket, ca. 1915. Weaver unknown, Penobscot (Old Town, Maine). Wicker-plaited black ash splints. Width 10.5 cm., height 12 cm. 8/7381

Tatting basket, ca. 1915. Weaver unknown, Penobscot (central Maine). Wicker-plaited natural and dyed black ash splints and braided sweet grass. Diam. 11 cm., height 12.5 cm. 11/4969

Ear of corn, 2003. Theresa Hoffman (b. 1958), Penobscot (Waterville, Maine). Natural and dyed wicker-plaited black ash splints with wart-weave overlay. Diam. 10 cm., height 42 cm. 26/1694

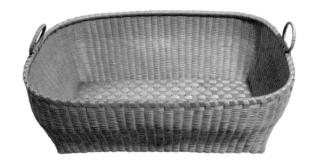

22/5862

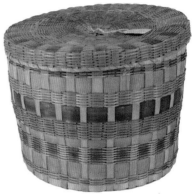

9/1520

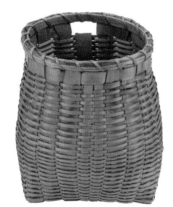

8/7381

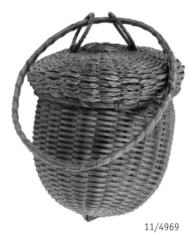

11/4969

26/1694

PEQUOT

Storage basket, ca. 1840. Weaver unknown, Pequot (southeastern Connecticut). Checker- and wicker-plaited black ash splints with painted decoration. Diam. 38 cm., height 27 cm. 21/8278

Covered storage basket, ca. 1850. Weaver unknown, Pequot (southeastern Connecticut). Checker- and wicker-plaited black ash splints with painted decoration. Length 37 cm., height 35 cm. 6/5745

POMO

Seed beater, ca. 1870. Weaver unknown, Pomo (central California). Wicker-plaited peeled willow shoots with handle wrapped with cotton twine and rim bound with split grapevine. Length 53 cm., width 31.5 cm., height 20.5 cm. 2/4427

Bowl, ca. 1900. Weaver unknown, Pomo (central California). Three-rod coiled willow with sedge root and bulrush-root stitches, applied shell beads and quail topknot feathers. Diam. 30 cm., height 14 cm. 4/8786

Storage bowl, ca. 1900. Weaver unknown, Pomo (central California). Three-rod coiled willow shoots, with sedge-root and bracken-fern stitches and sewn-on glass beads. Length 40 cm., height 10.5 cm. 4/8790

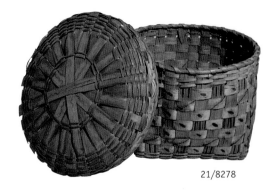

21/8278

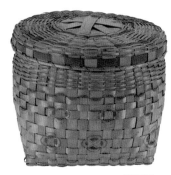

6/5745

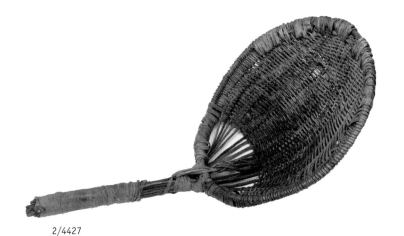

2/4427

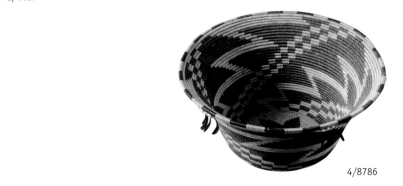

4/8786

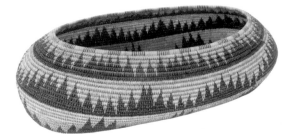

4/8790

POMO

Treasure basket, ca. 1900. Weaver unknown, Pomo (central California). Three-rod coiled willow shoots with sedge-root stitches with acorn-woodpecker feathers. Length 20 cm., height 7.5 cm. 23/5701

Miniature canoe-shaped baskets, ca. 1900. Weaver unknown, Pomo (central California). Single-rod coiled willow with sedge and bulrush-root stitches. Largest: length 1.9 cm., width 1 cm. 24/2116

Gift basket, ca. 1905. Weaver unknown, Pomo (central California). Three-rod coiled willow with willow and bracken-fern stitches, inset with mallard and meadowlark feathers; with applied clamshell disk beads and abalone-shell pendants. Diam. 22.9 cm., height 4.2 cm. 22/1912

Cooking bowl, ca. 1905. Weaver unknown, Pomo (central California). Plain-twined sedge and redbud. Diam. 42 cm., height 24.5 cm. 24/2107

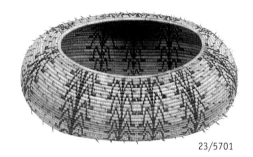

23/5701

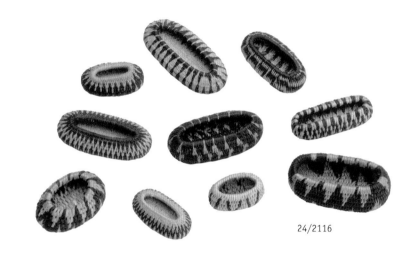

24/2116

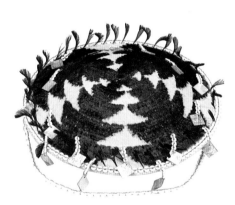

22/1912

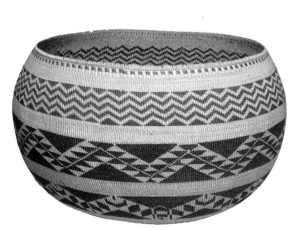

24/2107

POMO

Gift basket, 1925. Weaver unknown, Pomo (central California). One-rod coiled willow with sedge root and bracken-fern-root stitches and added quail topknot feathers. Diam. 16.5 cm., height 7 cm. 23/8581

Work tray, ca. 1930. Weaver unknown, Pomo (central California). Open plain-twined hazel shoots. Diam. 33.5 cm., height 7.6 cm. 24/4117

Bowl, ca. 1890. Weaver unknown, Pomo (central California). Three-rod coiled willow with sedge and dyed bulrush-root stitches. Diam. 26., height 10 cm. 24/2138

Miniature baskets, ca. 1910. Weaver unknown, Pomo (central California). Single-rod coiled willow and bracken fern. Largest: length 0.9 cm., width 0.5 cm. 24/8371

Work tray, ca. 1900. Weaver unknown, Central Pomo (central California). Lattice-twined on foundation of willow, with sedge root, dyed bulrush roots, and redbud shoots. Diam. 43 cm., height 12.5 cm. 15/6877

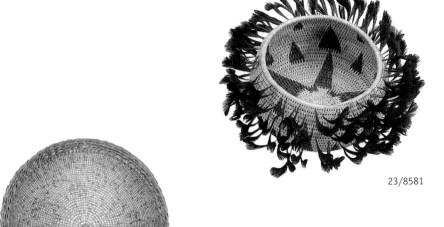

23/8581

24/4117

24/8371

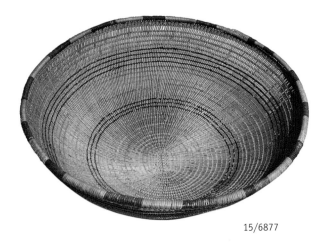

24/2138

15/6877

POMO

Bowl, ca. 1905. Mary Benson (1878–1930), Central Pomo (Yokaya, California). Three-rod coiled willow shoots with sedge and dyed bulrush-root stitches, magnesite-bead-disk start. Diam. 12.5 cm., height 7 cm. 24/2136

Bowl, ca. 1910. Mary Benson (1878–1930), Central Pomo (Yokaya, California). Single-rod coiled sedge and bulrush root, with magnesite-disk base. Diam. 11.9 cm., height 5.8 cm. 24/2122

Model cooking bowl, ca. 1905. Mary Benson (1878–1930), Central Pomo (Yokaya, California). Three-strand-twined sedge and red-bud. Diam. 20.5 cm., height 13.5 cm. 24/2125

Model cooking bowl, ca. 1905. Mary Benson (1878–1930), Central Pomo (Yokaya, California). Diagonal-twined redbud and sedge. Diam. 16 cm., height 10.5 cm. 24/2139

Cooking bowl, ca. 1920. Weaver unknown, Central Pomo (central California). Diagonal-twined sedge and redbud over willow foundation. Diam. 36.5 cm., height 22 cm. 24/2105

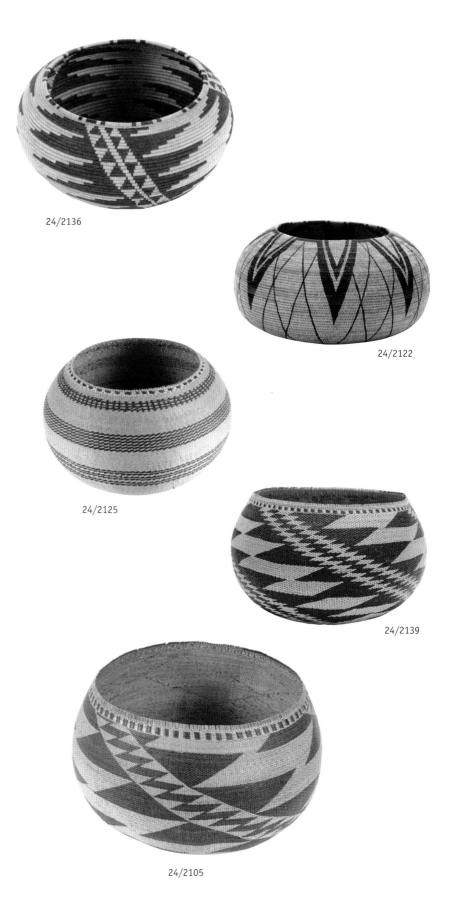

24/2136

24/2122

24/2125

24/2139

24/2105

POMO

Basket, ca. 1920. William Benson (1862–1937), Eastern Pomo (central California). Diagonal-twined natural and dyed sedge root and silk thread. Diam. 11.5 cm., height 8.6 cm. 24/2106

Cooking bowl, ca. 1910, attributed to Mary Benson (1878–1930), Central Pomo (Yokaya, California). Closed plain-, diagonal-, and wrap-twined willow and peeled and unpeeled redbud. Diam. 24 cm., height 15.5 cm. 24/2100

Beaded miniature basket, 2003. Julia Parker (b. 1929), Kashaya Pomo/Coast Miwok (Yosemite, California). Three-rod and one-rod coiled willow and sedge root with glass beads. Diam. 4.5 cm., height 2.5 cm. 26/2688

Beaded basket, ca. 1890. Weaver unknown, Southern Pomo (central California). Three-rod coiled willow with willow and bulrush-root stitches and sewn-on glass beads. Diam. 24.5 cm., height 8 cm. 4/8782

Baby-cradle earrings, 2003. Christine Hamilton (b.1947), Yokayo Pomo (Mendocino County, California). Open-twined willow and cotton thread. Length 2 cm., height 3 cm. 26/2573

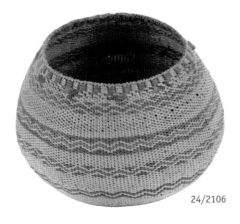

24/2106

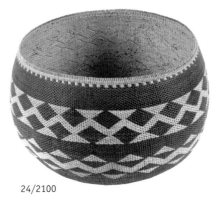

24/2100

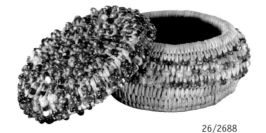

26/2688

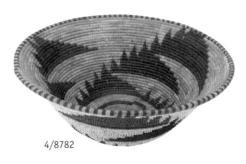

4/8782

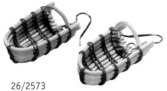

26/2573

PUEBLO

Bowl, ca. 1800. Weaver unknown, Pueblo (New Mexico). Bundle-and-stick coiled sumac and yucca stalk with natural and dyed sumac stitches. Diam. 31.5 cm., height 11 cm. 23/2812

Open burden basket, ca. 1880. Weaver unknown, Hopi Pueblo (Shongopavi, Arizona). Wicker-plaited willow shoots over support frame of cotton-wood sticks. Width 18.4 cm., height 50.8 cm. 9/440

Piki tray, ca. 1910. Weaver unknown, Hopi Pueblo (Shongopavi, Arizona). Two-over-two twill-plaited and wicker-plaited willow shoots; yucca-wrapped rim. Length 71 cm., width 56 cm. 9/446

Butterfly Maiden plaque, ca. 1970. Weaver unknown, Hopi Pueblo (Arizona). Wicker-plaited dyed peeled sumac or willow shoots; yucca-wrapped rim. Diam. 40.8 cm., height 3.2 cm. 26/1757

Made-for-sale bowl, ca. 1970. Weaver unknown, Hopi Pueblo (Second Mesa, Hopi Reservation, Arizona). Bundle-coiled grass with natural and dyed yucca stitches. Diam. 28 cm., height 26.4 cm. 26/1892

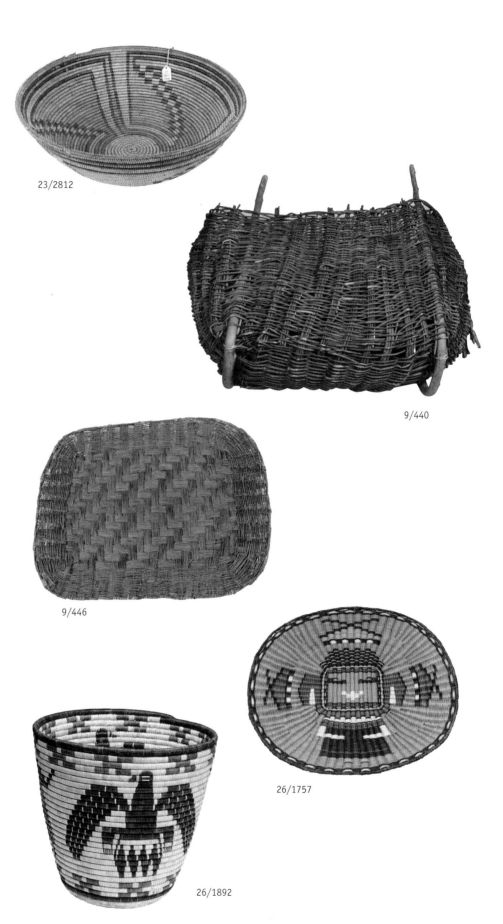

23/2812

9/440

9/446

26/1757

26/1892

PUEBLO

Tray, 2003. Sadie Marks, Hopi Pueblo (Sells, Arizona). Bundle-coiled bear grass with natural and sun-bleached-yucca, yucca-root, and martynia stitches. Diam. 55cm., height 12cm. 26/2616

Winnowing bowl, ca. 1970. Weaver unknown, Jemez Pueblo (New Mexico). Complex twill-plaited yucca leaves over tamarisk rim. Diam. 15 cm., height 10 cm. 26/1410

QUINAULT

Bowl, ca. 1900. Weaver unknown, Quinault (western Washington). Plain- and half-twist overlay-twined spruce root and bear grass. Diam. 24 cm., height 21 cm. 23/2756

SALISH

Small burden basket, ca. 1900. Weaver unknown, Coast Salish (Washington). Bundle-coiled split cedar root. Width 13.8 cm., height 15.5 cm. 20/8409

Covered trunk, ca. 1900. Weaver unknown, Fraser River Salish (Fraser River, British Columbia). Bundle-coiled cedar root with cedar-root stitching and imbricated design of phrag-mites and dyed and natural cherry bark. Length 76 cm., height 37.5 cm. 18/5143

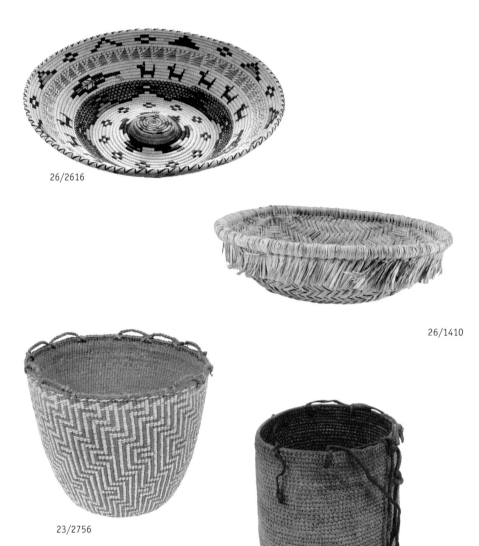

26/2616

26/1410

23/2756

20/8409

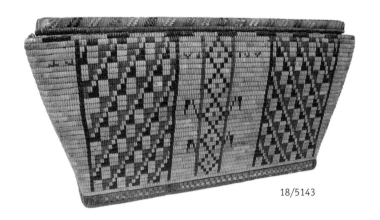

18/5143

SALISH

Lidded storage jar, ca. 1910. Weaver unknown, Thompson River Salish (Thompson River, British Columbia). Bundle-coiled cedar root with cedar-root stitches and imbricated design of phragmites and natural and dyed cherry bark. Diam. 34 cm., height 19 cm. 23/1045

Lidded storage jar, ca. 1920. Weaver unknown, Thompson River Salish (Thompson River, British Columbia). Bundle-coiled cedar root with cedar-root stitches and imbricated design of cherry bark and phragmites. Diam. 27 cm., height 21 cm. 23/1046

Sewing basket, ca. 1920. Weaver unknown, Thompson River Salish (Thompson River, British Columbia). Bundle-coiled cedar root with cedar-root stitches and imbricated design of cherry bark and phragmites; base of coiled, built-up rows. Diam. 30 cm., height 16.5 cm. 23/1053

Made-for-sale storage basket, ca. 1920. Weaver unknown, Thompson River, Salish (Thompson River, British Columbia). Bundle-coiled cedar root with cedar-root stitches and imbricated design of cherry bark and grass; base coiled on parallel cedar-wood slats. Width 23 cm., height 26.5 cm. 23/1057

Carrying basket, ca. 1920. Weaver unknown, Thompson River Salish (Thompson River, British Columbia). Bundle-coiled cedar root with cedar-root stitches and imbricated design of cherry bark and phragmites. Length 40 cm., height 25 cm. 23/1055

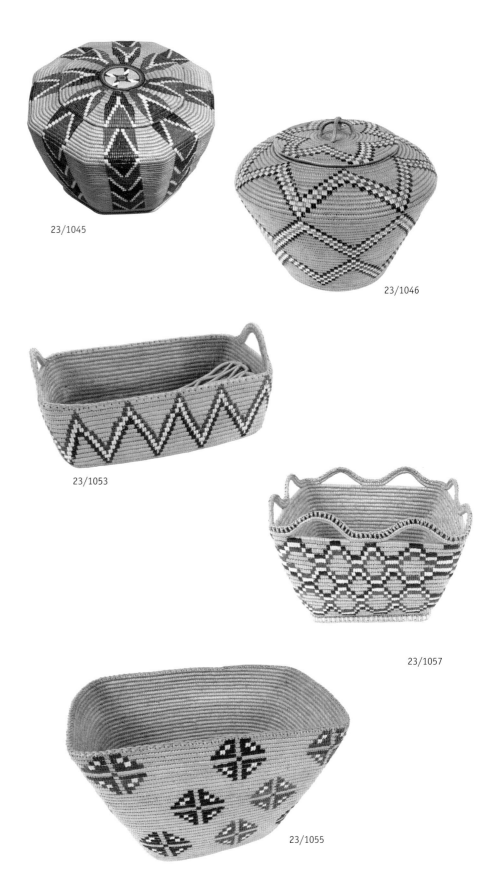

23/1045

23/1046

23/1053

23/1057

23/1055

SENECA

Closed burden basket with strap, ca. 1890. Weavers unknown, Seneca (Cattaraugus and Tonawanda Reservations, New York). Twill-plaited base with wicker-plaited black ash splint sides and braided bark strap. Diam. 36.5 cm., height 27.7 cm. 1688 and 1701

SKOKOMISH

Storage basket, ca. 1880. Weaver unknown, Skokomish (Washington). Wrap-twined bear grass and cherry bark on cedar-bark foundation. Length 57 cm., height 38 cm. 1197

TLINGIT

Russian sailor's hat, ca. 1820. Weaver unknown, Tlingit (southeastern Alaska). Plain closed-twined spruce root, false embroidered with natural and dyed bear grass. Diam. 39.5 cm., height 14.3 cm. 16/5272

Bowl, ca. 1900. Weaver unknown, Tlingit (Alaska). Closed-twined natural and dyed spruce root, false embroidered with natural and dyed canary grass and maidenhair-fern stems. Diam. 29 cm., height 24.5 cm. 15/6616

Made-for-sale bowl, ca. 1900. Weaver unknown, Tlingit (Alaska). Plain closed-twined natural and dyed spruce root, false embroidered with natural and dyed bear grass; base woven with alternating plaited and twined rows. Diam. 27.6 cm., height 20.5 cm. 16/7089

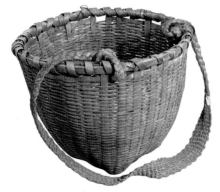

1688 and 1701

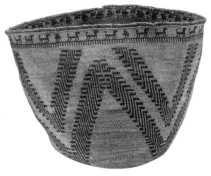

1197

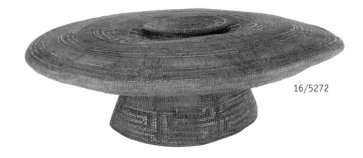

16/5272

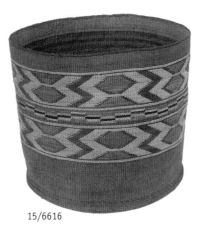

15/6616

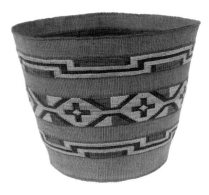

16/7089

TLINGIT

Bowl, ca. 1900. Weaver unknown, Tlingit (Alaska). Closed-twined natural and dyed spruce root, false embroidered with natural and dyed bear grass and maidenhair-fern stems. Diam. 25 cm., height 25.5 cm. 21/8017

Snuff container, ca. 1920. Weaver unknown, Tlingit (Alaska). Plain closed-twined spruce root, false embroidered with natural and dyed bear grass. Diam. 5 cm., height 6.5 cm. 15/6646

Bowl, ca. 1920. Weaver unknown, Tlingit (Alaska). Plain closed-twined spruce root, false embroidered with dyed bear grass. Diam. 19 cm., height 13.5 cm. 16/8293

Shot pouch and cover, 2003. Teri Rofkar, Tlingit (Sitka, Alaska). Plain closed-twined spruce root, false embroidered with maidenhair fern and canary grass. Diam. 5., height 4.8 cm. 26/2576

Black-banded basket, 2003. Lisa Telford (b. 1957), Haida (Everett, Washington). Plain closed-twined natural and dyed spruce root. Diam. 30.5 cm., height 45.7 cm. 26/2705

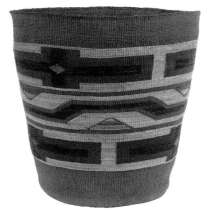

21/8017

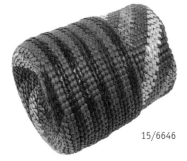

15/6646

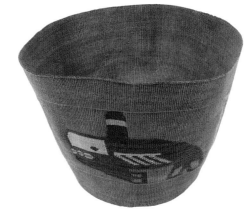

16/8293

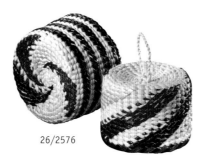

26/2576

26/2705

TOHONO O'ODHAM

Open burden basket, ca. 1890. Weaver unknown, Tohono O'odham (southern Arizona). Looped agave-fiber webbing over saguaro-cactus sticks with horsehair wrapping and bias-plaited yucca-fiber harness. Width 84 cm., height 56.5 cm. 10/5430

Made-for-sale wastebasket, ca. 1970. Weaver unknown, Tohono O'odham (Big Field, Arizona). Bundle-coiled split yucca leaves with yucca and martynia stitches. Diam. 30.5 cm., height 27.5 cm. 25/5378

Basket, ca. 1970. Weaver unknown, Tohono O'odham (southern Arizona). Bundle-coiled cattails with natural and sun-bleached-yucca, yucca-root, and martynia stitches. Diam. 28.9 cm., height 35.3 cm. 26/163

Tray, ca. 1970. Isadora Rios, Tohono O'odham (southern Arizona). Bundle-coiled cattail with yucca and martynia stitches. Diam. 30 cm., height 3.4 cm. 26/1777

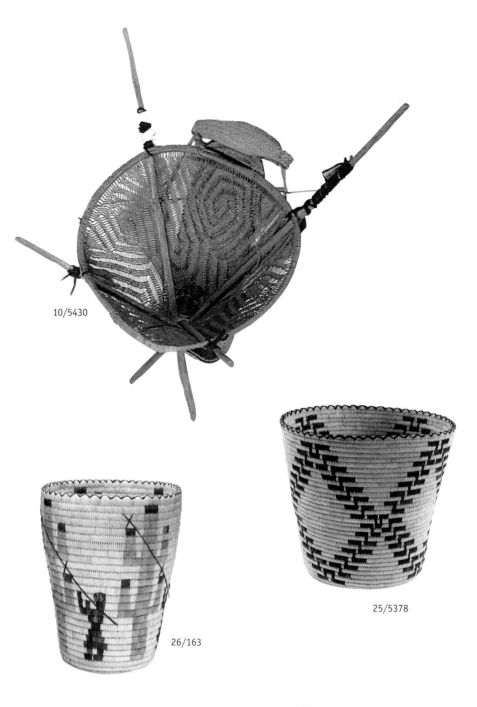

10/5430

26/163

25/5378

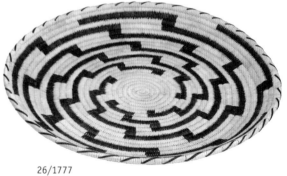

26/1777

TOHONO O'ODHAM

Basket, 2003. Terrol Johnson, Tohono O'odham (Tucson, Arizona). Cast-bronze gourd with bundle-coiled bear grass. Diam. 21 cm., height 25 cm. 26/2578

Miniature bowl, 2003. Lola Thomas, Tohono O'odham (Chui Chui, Arizona). Bundle-coiled yucca with willow and martynia stitches. Diam. 11.5 cm., height 4 cm. 26/2614

Tray, 2003. Virginia Lopez (b. 1946), Tohono O'odham (Sells, Arizona). Bundle-coiled bear grass with yucca and martynia stitches. Diam. 71 cm., height 10 cm. 26/2615

TOLOWA

Food bowl, ca. 1890. Weaver unknown, Tolowa (northwestern California). Plain closed-twined hazel shoots and conifer root with half-twist overlay design in bear grass. Diam. 21.5 cm., height 10 cm. 8625

Cooking bowl, ca. 1900. Weaver unknown, possibly Tolowa (northwestern California). Plain closed-twined hazel shoots and conifer root with half-twist overlay design in bear grass. Diam. 22 cm., height 16 cm. 15/6536

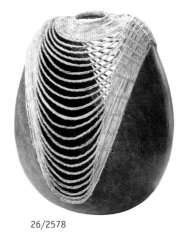

26/2578

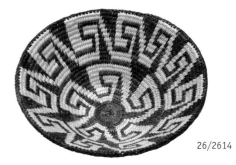

26/2614

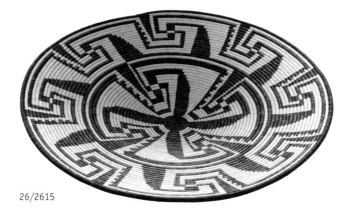

26/2615

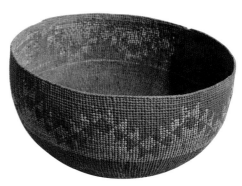

8625

15/6536

TSIMSHIAN

Souvenir basket, ca. 1890. Weaver unknown, Tsimshian (Metlakatla, Alaska). Plain closed-twined spruce root, false embroidered with maidenhair-fern stems and canary grass. Diam. 11.5 cm., height 9 cm. 24/7216

Rattle-top lid basket, 2003. Loa Ryan, Tsimshian (Bremerton, Washington). Closed-twined red cedar bark, false embroidered with canary grass. Diam. 18 cm., height 17.5 cm. 26/2613

TUBATULABAL (KERN RIVER)

Serving or cooking bowl, ca. 1900. Weaver unknown, Tubatulabal (Kern County, California). Bundle-coiled deer-grass with sedge, martynia, bracken-fern, and yucca-root stitches. Diam. 40 cm., height 20.3 cm. 24/2844

Woman's burden hat, ca. 1880. Weaver unknown, Tubatulabal (Kern County, California). Bundle-coiled willow with sumac, bracken-fern-root, martynia, and yucca-root stitches. Diam. 20 cm., height 10.8 cm. 22/1925

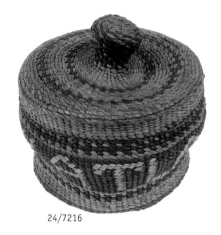

24/7216

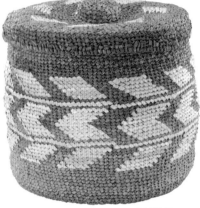

26/2613

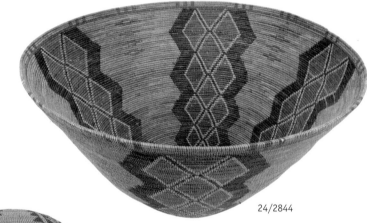

24/2844

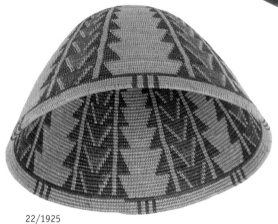

22/1925

WALAPAI

Parching and winnowing tray, ca. 1910. Weaver unknown, Walapai (Arizona). Diagonal- and plain-twined whole and split willow shoots. Diam. 50 cm., height 10 cm. 23/1139

WAMPANOAG

Covered storage basket, ca. 1830. Weaver unknown, Wampanoag (New Bedford, Massachusetts). Checker- and wicker-plaited hickory (?) splints with painted decoration. Diam. 50 cm., height 10 cm. 3/6798

Closed burden basket, ca. 1900. Weaver unknown, Mashpee Wampanoag (Cape Cod, Massachusetts). Checker-plaited hickory (?) splints with strap of bias-plaited splints. Diam. 40 cm., height 38.6 cm. 1/8697

WAPPO

Gift basket, ca. 1900. Weaver unknown, Wappo (Sonoma County, California). Single-rod coiled willow shoots with sedge stitches and sewn-on glass beads. Diam. 7 cm., height 3.7 cm. 13/5391

23/1139

3/6798

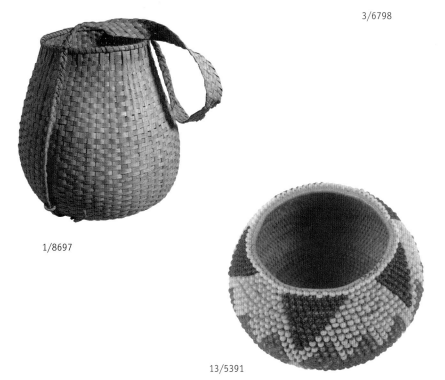

1/8697

13/5391

WASCO

Sally bag, ca. 1870. Weaver unknown, Wasco (Washington). Closed wrap-twined natural and dyed rushes over hemp foundation, with cotton-cloth rim. Width 30 cm., height 22.5 cm. 8633

Sally bag, ca, 1890. Weaver unknown, Wasco (Washington). Wrap-twined natural and dyed rushes over hemp foundation. Diam. 20 cm., height 19.5 cm. 13/8642

Sally bag, ca. 1890. Weaver unknown, Wasco (Washington). Closed, wrap-twined rushes and cornhusk over cattail-string foundation, with leather rim and carrying straps. Diam. 23 cm., height 23.5 cm. 13/8647

Sally bag, ca. 1900. Weaver unknown, Wasco (Washington). Closed wrap-twined natural and dyed rushes over hemp foundation, with cotton velveteen rim. Diam. 18.5 cm., height 17.5 cm. 13/8644

Sally bag, ca. 1915. Weaver unknown, Wasco (Washington). Closed wrap-twined natural and dyed rushes over rush-cordage foundation, with leather rim. Diam. 16 cm., height 16 cm. 13/8654

Sally bag, 2003. Pat Courtney Gold, Wasco–Tlingit (Scappoose, Oregon). Closed wrap-twined acrylic yarn over Hungarian hemp foundation. Diam. 15.5 cm., height 26.5 cm. 26/2617

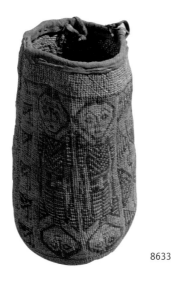

8633

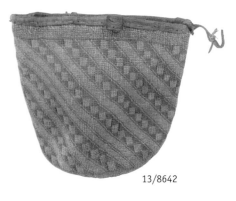

13/8642

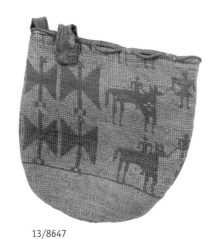

13/8647

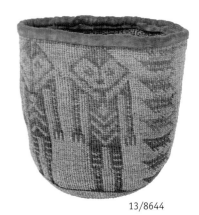

13/8644

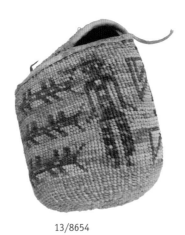

13/8654

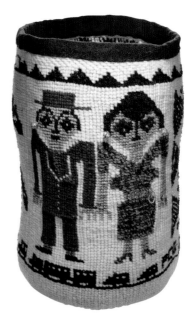

26/2617

WASHOE

Cooking basket, ca. 1900. Weaver unknown, Washoe (Nevada). Three-rod coiled willow shoots with willow and bracken-fern stitches; whip-stitch rim. Diam. 33 cm., height 16.5 cm. 1198

Made-for-sale basket, ca. 1930. Weaver unknown, Washoe (Nevada). Single-rod coiled willow shoots with willow and redbud stitches. Diam. 34 cm., height 22 cm. 24/7770

WINTU

Closed burden basket, ca. 1890. Weaver unknown, Wintu (Shasta County, California). Four-strand full-twist overlay-twined conifer root and bear grass with oak rim reinforcement wrapped with wild grapevine. Diam. 51.5 cm., height 53.8 cm. 19/8179

YAVAPAI

Bowl, ca. 1900. Weaver unknown, Yavapai (western Arizona). Three-rod coiled willow shoots with willow, martynia, and yucca root stitches. Diam. 34.5 cm., height 9 cm. 24/2850

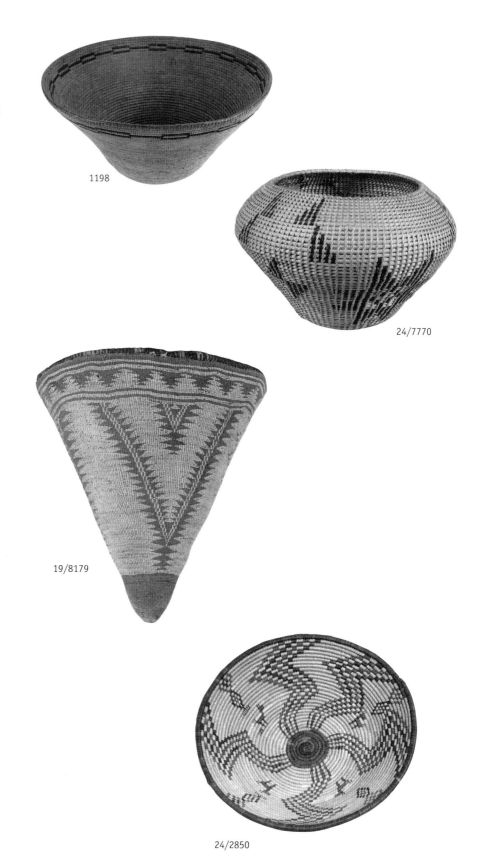

1198

24/7770

19/8179

24/2850

YOKUTS

Gift basket, ca. 1890. Weaver unknown, Yokuts (southern central California). Bundle-coiled deer-grass stems with bracken-fern-root and split bird-quill stitches. Diam. 21 cm., height 16.5 cm. 1/109

Open burden basket, ca. 1900. Weaver unknown, Yokuts (southern central California). Plain and diagonal open-twined peeled willow shoots. Diam. 49 cm., height 62.7 cm. 5/869

Sifting tray, ca. 1900. Weaver unknown, Yokuts (southern California). Bundle-coiled grass stems with sedge and bracken-fern stitches. Diam. 47 cm., height 2 cm. 20/6940

Cooking bowl, ca. 1900. Mary Dick Topino (ca. 1868–1923), Yokuts (southern central California). Bundle-coiled deer-grass stems with sedge, bracken-fern, and redbud stitches. Diam. 34.2 cm., height 14.5 cm. 20/8325

Serving or cooking bowl, ca. 1900. Weaver unknown, Yokuts (Tulare County, California). Bundle-coiled deer-grass stems with sedge, bracken-fern, and redbud stitches. Diam. 54 cm., height 28.5 cm. 24/2846

Cooking bowl, ca. 1900. Weaver unknown, Yokuts (Tulare County, California). Bundle-coiled deer-grass with sedge, redbud, and bracken-fern-root stitches. Diam. 35 cm., height 21.5 cm. 24/2845

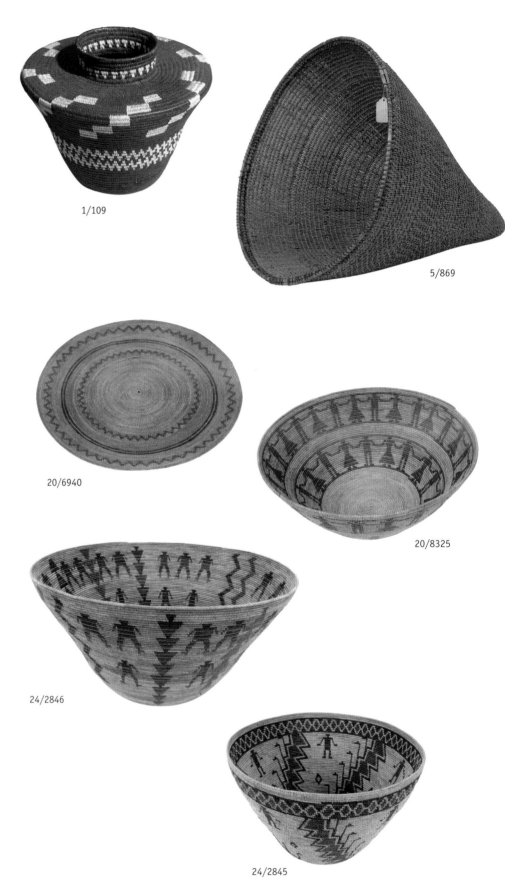

1/109

5/869

20/6940

20/8325

24/2846

24/2845

YUP'IK ESKIMO

Covered basket, ca. 1900. Weaver unknown, Yup'ik Eskimo (Nushagak, Alaska). Bundle-coiled grass with dyed and natural beach-grass stitches and wool yarn accents. Diam. 23 cm., height 17 cm. 15/4626

Jar and cover, 2000. Theresa Moses, Yup'ik Eskimo (Toksook Bay, Alaska). Bundle-coiled beach grass with dyed and natural beach-grass stitches. Diam. 38 cm., height 30.5 cm. 25/5180

YUROK

Open burden basket, ca. 1890. Weaver unknown, Yurok (northwestern California). Twined hazel or willow shoots with four-strand one-twist over-lay band of bear grass and woodwardia fern at rim. Diam. 48 cm., height 40.6 cm. 16/9694

Jump Dance basket, ca. 1915. Weaver unknown, Yurok (northwestern California). Four-strand half-twist twined hazel sticks with overlay of bear grass and maidenhair-fern stems; painted leather ends and attached feathers. Diam. 36 cm., height 40.5 cm. 12/2813

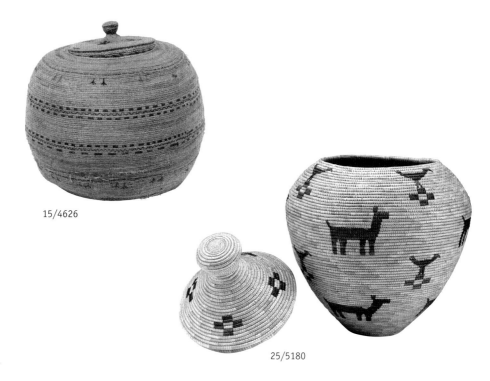

15/4626

25/5180

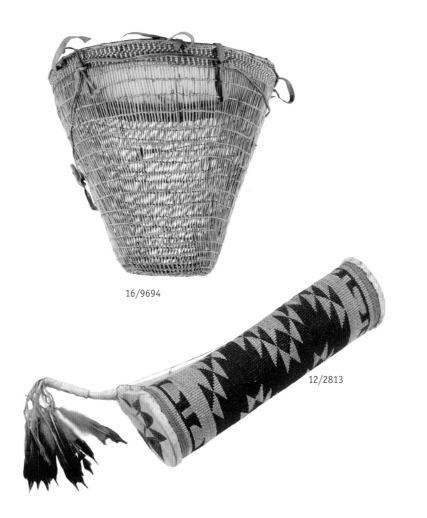

16/9694

12/2813

Bibliography

American Indian Art Magazine. Basketry Issue, Autumn, 1979.

American Indian Art Magazine. Basketry Issue, Summer, 1999.

Abel-Vidor, Suzanne, Dot Brovarney, and Susan Billy. *Remember your Relations: the Elsie Allen Baskets, Family and Friends*. Ukiah, California: Grace Hudson Museum, 1996.

Allen, Elsie, with Vinson Brown. *Pomo Basketmaking: a Supreme Art for the Weaver*. Healdsburg, California: Naturegraph Publishers, 1972.

Barrett, Samuel A. *Pomo Indian Basketry*. Berkeley, California: Phoebe Hearst Museum of Anthropology, University of California, 1984.

Bates, Craig, and Martha J. Lee. *Tradition and Innovation: A Basket History of the Indians of the Yosemite–Mono Lake Area*. Yosemite, California: Yosemite Association, 1990.

Benedict, Salli. 1982 "Mohawk Indian Basketry." In *American Indian Basketry Magazine,* 1982, 9: 9–19.

Benedict, Salli, and Judy Lauersons. *Teionkwahontasen: Basketmakers of Akwesasne*. Hogansburg, New York: The Akwesasne Museum, 1983.

Bibby, Brian. *The Fine Art of California Indian Basketry*. Sacramento, California: Crocker Art Museum, 1996. *All Roads Are Good: Native Voices on Life and Culture*. Washington: Smithsonian Institution Press, 1994. pp. 196–207.

Billy, Susan. "So the Spirit Can Move Freely." In *All Roads Are Good: Native Voices on Life and Culture*. Washington: Smithsonian Institution Press, 1994. pp. 196–207.

Brasser, Ted J. *A Basketful of Indian Culture Change*. Ottawa, Ontario: Canadian Ethnology Service Mercury Series 22, National Museums of Canada, 1975.

Coe, Ralph T. *Lost and Found Traditions: Native American Art 1965–85*. Seattle, Washington: University of Washington Press and American Federation of Arts, 1986.

Cohodas, Marvin. "The Breitholle Collection of Washoe Basketry." In *American Indian Art Magazine*, Winter, 1984, pp. 38–49.

Cohodas, Marvin. *Basket Weavers for the California Curio Trade: Elizabeth and Louise Hickox*. Tucson, Arizona: The University of Arizona Press, 1997.

Cohodas, Marvin. *Degikup: Washoe Fancy Basketry 1895–1935*. Vancouver, British Columbia: The Fine Arts Gallery of the University of British Columbia, 1979.

Clarke Memorial Museum. *The Hover Collection of Karuk Baskets*. Eureka, California: Clarke Memorial Museum, 1985.

Dalrymple, Larry. *Indian Basketmakers of California and the Great Basin*. Santa Fe, New Mexico: Museum of New Mexico Press, 2000.

Dalrymple, Larry. *Indian Basketmakers of the Southwest*. Santa Fe, New Mexico: Museum of New Mexico Press, 2000.

Dawson, Lawrence and James Deetz. *A Corpus of Chumash Basketry*. Los Angeles, California: Department of Anthropology University of California, 1965.

Dick, Linda E., Lorrie Planas, Judy Polanich, Craig D. Bates, and Martha J. Lee. *Strands of Time: Yokuts, Mono and Miwok Basketmakers*. Fresno, California: Fresno Metropolitan Museum, 1988.

Eckstorm, Fannie Hardy. *The Handicrafts of the Modern Indians of Maine*. Bar Harbor, Maine: Robert Abbe Museum, 1932.

Elsasser, Albert B. "Basketry." In *Handbook of North American Indians*, vol. 8, California, edited by Robert F. Heizer. Washington, D.C.: Smithsonian Institution, 1978.

Emmons, George T. *The Basketry of the Tlingit*, Memoirs, American Museum of Natural History, vol. 3, part 2, 1903.

Fowler, Catherine S. and Lawrence E. Dawson. "Ethnographic Basketry." In *Handbook of North American Indians*, vol. 2, Great Basin, edited by Robert F. Heizer. Washington, D.C.: Smithsonian Institution, 1986.

Fulkerson, Mary Lee. *Weavers of Tradition and Beauty: Basketmakers of the Great Basin*. Reno, Nevada: University of Nevada Press.

Herold, Joyce. "Chumash Baskets from the Malaspina Collection." *American Indian Art Magazine*, Winter, 1977, pp. 68–75.

Hill, Sarah H. *Weaving New Worlds: Southeastern Cherokee Women and Their Basketry*. Chapel Hill, North Carolina: The University of North Carolina Press, 1997.

Hill, Richard W., Sr. "The Legacy of Baskets." In *Creation's Journey: Native American Identity and Belief,* Tom Hill and Richard W. Hill, Sr., eds. Washington: Smithsonian Institution Press, 1994, pp. 132–133.

The Hover Collection of Karuk Baskets. Eureka, California: Clarke Memorial Museum, 1985.

James, George Wharton. *Indian Basketry*. New York: Henry Malkan, 1909. Reprint, 1972, New York: Dover Publications, Inc. 1972.

Jones, Joan Megan. *Northwest Coast Indian Basketry: A Stylistic Analysis*. Ph.D. dissertation. Seattle: University of Washington, 1976.

Kissell, Mary Lois. *Basketry of the Papago and Pima Indians*. Glorieta, New Mexico: The Rio Grande Press, Inc., 1972.

Kuneki, Nettie, Elsie Thomas, Marie Slockish. *The Heritage of Klickitat basketry: A History and Art Preserved*. Portland, Oregon: The Oregon Historical Society, 1982.

Lee, Molly. *Baleen Basketry of the North Alaskan Eskimo*. Seattle, Washington: University of Washington Press, 1998.

Leftwich, Rodney L. *Arts and Crafts of the Cherokee*. Cherokee, North Carolina: Cherokee Publications, 1970.

Lester, Joan A. *We're Still Here: Art of Indian New England*. Boston, Massachusetts: The Children's Museum, 1987.

Lester, Joan A. *History on Birchbark: The Art of Tomah Joseph, Passamaquoddy*. Bristol, Rhode Island: Haffenreffer Museum of Anthropology, Brown University, 1993.

Lopez, Raul A., and Christopher L. Moser, eds. *Rods, Bundles, and Stitches: A Century of Southern California Indian Basketry*. Riverside, California: Riverside Museum Press, 1981.

Marr, Carolyn J. "Wrapped Twined Baskets of the Southern Northwest Coast: A New Form with an Ancient Past." *American Indian Art Magazine*, Summer, 1988, pp. 54–63.

Mason, Otis Tufton. *Aboriginal Indian Basketry*. New York: Doubleday, Page, 1904. Reprint, 1970, Glorieta: The Rio Grande Press, Inc.

McBride, Bunny. *Our Lives in Our Hands: Micmac Indian Basketmakers*. Gardiner, Maine: Tilbury House, Publishers, 1990.

McGreevy, Susan Brown. *Indian Basketry Artists of the Southwest: Deep Roots, New Growth*. Santa Fe, New Mexico: School of American Research Press, 2001.

McMullen, Ann, and Russell G. Handsman. *A Key into the Language of Woodsplint Baskets*. Washington, Connecticut: The American Indian Archaeological Institute, 1987.

Medford, Jr., Claude. "Chitimacha Split Cane Basketry: Weaver and Designs." *American Indian Art Magazine*, Winter, 1977, pp. 56–61.

Mowat, Linda, Howard Morphy, and Penny Dransart, eds. *Basketmakers: Meaning and Form in Native American Baskets*. Oxford, UK: Pitt Rivers Museum, 1992.

Nordquist, D.L. and G.E. Nordquist. *Twana Twined Basketry*. Ramona, California: Acoma Books, 1983.

O'Neale, Lila M. *Yurok–Karok Basket Weavers*. Berkeley, California: Phoebe Hearst Museum of Anthropology, University of California, 1932.

Paul, Frances. *Spruce Root Basketry of the Alaska Tlingit*. Lawrence: United States Department of the Interior, 1944. Reprint, 1970, The Sheldon Jackson Museum.

Pelletier, Gaby. *Abenaki Basketry*. Ottawa, Ontario: Canadian Ethnology Service Mercury Series 85, National Museums of Canada, 1982.

"Pomo Indian Basket Weavers: Their Baskets and the Art Market." *Expedition*, vol. 40, no. 1, 1998.

Porter, Frank W., ed. *The Art of Native American Basketry: A Living Legacy*. New York: Greenwood Press, 1990.

Purdy, Carl. *Pomo Indian Baskets and Their Makers*. Ukiah, California: Mendocino County Historical Society.

Roberts, Helen H. *Basketry of the San Carlos Apache Indians*. Glorieta, New

Mexico: The Rio Grande Press, Inc., 1972.

Robinson, Bert. *The Basket Weavers of Arizona*. Albuquerque, New Mexico: University of New Mexico Press, 1954.

Roosevelt, Anna Curtenius and James G. E Smith, eds. *The Ancestors: Native Artisans of the Americas*. New York: Museum of the American Indian, 1975

Sanipass, Mary Ann. *Baskadegan: Basket Making Step-by-Step*. Madawaska, Maine: Saint John Valley Publishing Company, 1990.

Schlick, Mary Dodds. *Columbia River Basketry: Gift of the Ancestors, Gift of the Earth*. Seattle, Washington: University of Washington Press, 1994.

Smith, Lillian. "Three Inscribed Chumash Baskets with Designs from Spanish Colonial Coins." *American Indian Art Magazine*, Summer, 1982, pp.62–68.

Speck, Frank G. *Eastern Algonkian Block-Stamp Decoration: A New World Original or an Acculturated Art*. Trenton, New Jersey: The Archaeological Society of New Jersey, Research Series no. 1, 1947.

Teiwes, Helga. *Hopi Basket Weaving: Artistry in Natural Fibers*. Tucson, Arizona: The University of Arizona Press, 1996.

Thompson, Nile, and Carolyn Marr. *Crow's Shells: Artistic Basketry of Puget Sound*. Seattle, Washington: Dushuyay Publications, 1983.

Turnbaugh, Sarah Peabody, and William A. Turnbaugh.

Indian Baskets. West Chester, Pennsylvania: Schiffer Publishing Ltd., 1986.

Wilson, Renate. "Basket Makers of Mount Currie." *The Beaver*, Autumn, 1964.

Wheat, Margaret M. *Survival Arts of the Primitive Paiutes*. Reno, Nevada: University of Nevada Press, 1967.

Whiteford, Andrew Hunter. *Southwestern Indian Baskets: Their History and Their Makers*. Santa Fe, New Mexico: School of American Research Press, 1988.

Whiteford, Andrew Hunter. "Fiber Bags of the Great Lakes Indians." *American Indian Art Magazine*, Summer, 1977, pp. 52–64.

Whiteford, Andrew Hunter. "Fiber Bags of the Great Lakes Indians, part 2." *American Indian Art Magazine*, Winter, 1977, pp. 40–47.

Whitehead, Ruth Holmes. *Elitekey: Micmac Material Culture from 1600 A.D. to the Present*. Halifax, Nova Scotia: The Nova Scotia Museum, 1980.

Whitehead, Ruth Holmes. *Micmac Quillwork*. Halifax, Nova Scotia: The Nova Scotia Museum, 1982.

Wyckhoff, Lydia, ed. *Woven Worlds: Basketry from the Clark Field Collection at the Philbrook Museum of Art*. Tulsa, Oklahoma: The Philbrook Museum of Art, Inc., 2001.